YSL

STYLE ICON

DAN JONES

ILLUSTRATED BY
SANDRA SUY

YSL

STYLE ICON

THE DEFINITIVE DESIGNS AND MOMENTS
FROM FASHION POWERHOUSE YVES SAINT LAURENT

CHAPTER 1	THE DEBUT *1950-63*	10
CHAPTER 2	CREATING THE SIXTIES *1963-69*	30
CHAPTER 3	DEFINING FASHION *1969-80*	58
CHAPTER 4	HIGH DRAMA *1980-2000*	88
CHAPTER 5	BIG BUSINESS *2000-2014*	112
CHAPTER 6	MODERN ERA *2014-24*	144

ABOUT THE AUTHOR/ILLUSTRATOR 172
ACKNOWLEDGEMENTS 172
INDEX 174

NAKED TALENT

The iconic celebrity designer

Yves Mathieu-Saint-Laurent was born on 1st August 1936, in Oran, Algeria, auspiciously at the height of Leo season. His family had carved out a golden life in the desert of what had been a French colony since 1830; his mother, Lucienne, had the dressmaker visit once a week and little Yves would sit in on all her fittings. He was shy, loved to draw and was, by most measures, adorably pretentious, inviting his mother and sisters to haute couture presentations that he staged with paper dolls. He was hero-worshipped at home, but school was a different story. Oran was a town for jocks, not nerds, and definitely not girly boys who would grow up to be gay. Yves was impossibly tall and gangly, nervous and horribly bullied; he developed anxiety that haunted him throughout his life.

Winning the International Wool Secretariat's design competition at the age of 18, up against six thousand anonymous contestants, changed everything. He flew to Paris with Lucienne, nervously accepted the awards (he was the only person to win two), and went on to meet a fashion contact of his father's to show off his winning sketches. When they walked past 30 Avenue Montaigne, Christian Dior's legendary maison de couture, he said, 'Maman, it won't be long before I'm working in there', or so the legend goes. It would have been the sign of an insufferable ego had it not turned out to be true. Years later, Yves not only worked closely with Christian Dior, but he also took over the maison after the surprise death of the grand couturier himself. Through all his nervous anxiety, Yves had steely self-belief.

At the age of 21, and after just a short time at Dior, Yves Saint Laurent became the world's youngest head couturier overnight; his Spring/

Summer 1958 haute couture collection saved the house and was perfectly pitched, a respectful continuation of Dior's work but with Yves' youthful approach. That same week he agreed to have dinner with Pierre Bergé, the sexually liberated and confident industrialist, eight years his senior. They fell in love and were living together within months; Yves had met the man who would transform him and his work into the world's most legendary and beloved luxury brand, and Pierre had met the man he could make king. It wouldn't be easy, and there would be challenges along the way (Yves' other Dior collections were not as universally loved), but they would do it together – and they did.

They opened their own haute couture maison in 1960 and built their forever brand from there. Yves was the world's most famous and loved fashion celebrity of the 1970s and early '80s, creating a series of iconic styles and a community of muses, artists and performers, securing Paris its position as the epicentre of cool.

As the pressure of maintaining the top spot grew, Yves' anxieties turned into addictions and periods of reclusiveness; when his star shone the brightest, he would often be struggling with his own demons in the dark. But there were golden summers in Marrakech, feuds and fights with Karl Lagerfeld, BDSM affairs and endless parties, art purchases and trays of cannabis. But then came the AIDS epidemic to which Yves, Pierre and others in the fashion world lost many of their friends (the pair used the brand to raise awareness of the disease and even sent out free condoms to men in Parisian neighbourhoods). There was also the artistry of Pierre's investments and the tireless energy of Yves' creativity until he closed the brand's haute couture business in 2002, with a retrospective fashion show that captivated Paris, if not the world.

Yves Saint Laurent passed away in 2008, but the brand goes on. Yves' ashes were scattered at his beloved Majorelle gardens in Morocco and in 2017, just before his own death, Pierre opened the Musée Yves Saint Laurent in Marrakech: the perfect way to commemorate the man he made king.

CHAPTER 1

THE DEBUT

1950 –63

YSL INSPIRATIONS

PAPER DOLLS

In May 1950, when Yves Saint Laurent was just 14 years old, a production of Molière's *The School for Wives* came to Yves' hometown of Oran, Algeria. The sets, the costumes and the theatricality blew his teenage mind. Afterwards, he secretly cut up his mother's dresses and used the scraps to style paper dolls made from cutouts from magazines like *Paris Match* and *Vogue*. He recreated the *School for Wives* sets in miniature and built a large wooden crate version of the Théâtre de l'Athénée in Paris that had first created the show (a theatre that his partner, Pierre Bergé, would one day buy, and for whom Yves would design sets and costumes). There, he put on performances for his mother, Lucienne, and sisters Michèle and Brigitte.

He later created another diorama, the Yves Mathieu Saint Laurent Haute Couture Place Vendôme, and used paper decorated with gouache, ink and watercolour to dress his paper dolls. If these were childish scrawls and his mother and sister were politely humouring him, things quickly changed. He devoted himself to his fashion sketches and a little more than three years later, at the age of 18, he found himself on stage in Paris. He had entered the International Wool Secretariat's design competition where six thousand contestants sent in fashion sketches anonymously to be judged by the cream of Paris haute couture. Incredibly, Yves won in two categories, accidentally stealing the spotlight from another, older winner, Karl Lagerfeld. Yves' life of fashion and feuds had just begun.

DEBUT AT DIOR
1957

On 15 November 1957, Yves Saint Laurent '...stepped out of obscurity' and into his first press conference as the successor of Dior, wrote *The New York Times*. Christian Dior had died weeks earlier, leaving no sketches and no direction – just Yves and Dior's studio managers to create a whole haute couture collection in less than three months. Then, on 30 January 1958, they did just that: Yves' Dior debut finally took to the runway.

Years earlier, in 1953, a 17-year-old Yves had met Michel de Brunhoff, editor-in-chief of *Vogue* (Paris), to show him his fashion sketches. At the time, De Brunhoff told him to go back to school. Yves did, but that wasn't the end of it: they met again in '55 – but this time, De Brunhoff was impressed. Yves' 50 or so sketches reminded him of Christian Dior's own design handwriting, and he arranged for the pair to meet: Dior hired him on the spot. Yves could not have had a better tutor, and Dior was generous with his trust.

In the summer before his unexpected death, Christian Dior had written to his business partner Jacques Rouet, describing Yves as '... an immense talent', and saying 'I consider him to be the father of 34 out of the 180 designs' of his previous collection. 'I think the time has come to reveal it to the press. My prestige won't suffer from it.'

Now, months later, Yves' Dior debut show received 'a standing ovation', according to the Musée Yves Saint Laurent – it was a hit! 'The press was in a state of euphoria ... while groups of admirers wept with joy.' And days later, something else extraordinary happened: Yves had dinner with Pierre Bergé, the French industrialist, who would become his future partner in business and love (they were living together just six months later).

THE TRAPÈZE LINE

1958

The maison de couture was in mourning. Christian Dior had died suddenly, and the fashion house he had created had somehow chosen young Yves Saint Laurent, one of Dior's protégés, as his successor – how was he to carry such a burden? At the age of just 21, Yves became the youngest leader of an haute couture house ever and it happened almost overnight. Christian Dior's iconic New Look – voluminous skirts with tiny waists to accentuate the female shape – had already set the mood. Yves would have to honour what had gone before and offer something fresh, something he might become known for himself. And so, in 1958, Yves Saint Laurent debuted what became known as the Trapèze collection; he loosened Dior's cinched waist and created a flowing, freeform silhouette using less fabric and a lighter touch; it was a hit!

Drawing on the political atmosphere of the time, Yves' less formal, less overtly 'feminine' trapeze shapes seemed to be a nod to Women's Liberation but were clearly the descendants of Christian Dior's own creations. Yves revisited the shape again and again, notably in 1965 with his own Mondrian pieces, which were an echo of his debut collection. At that point his trapeze dresses were even simpler: no sleeves, no collar, no showiness; but back in '58, it was all about delicate sparkle. This Dior silk trapeze dress, the lauded L'Eléphant Blanc, has a secret inner layer hiding a boned corset for shape, with an embellished top layer featuring metallic thread with plastic and glass beading, a shimmer of rhinestones.

THE BEATNIK LOOK

1960

With the success of his haute couture debut at Christian Dior in 1958, Yves Saint Laurent drew from a fascinating art-edged subculture for his Autumn/Winter 1960 collection. The Beatniks, the chic young superfans of the Beat poets and musicians, were well-known despite their small numbers. To some, they were the last word in cool, and to the media they were both celebrated and parodied, but they were dangerously anti-establishment to others. To Yves, they represented the direction fashion was going in and he infused his collection with Beatnik black tones and leather. It was a near disaster: his clientele, the conservative moneyed savants of the haute couture world, were unimpressed. This just wasn't what couture was for!

But in the decades since, the star piece of that collection, his 'Chicago' leather jacket – clearly a spin on the classic leather biker – rendered in black crocodile, trimmed with mink and lined with silk, has become an icon. The collection made it clear to the great fashion house and perhaps to Yves himself that he was maybe too youthful, and too democratic in his creative approach. His connection with youth-led culture did not wane – he had identified a second, powerful fashion fanbase in the young and, a few years later, created collections just for them through his Rive Gauche ready-to-wear line.

THE FIRST YVES SAINT LAURENT COLLECTION

1962

Just as his creative confidence soared, Yves Saint Laurent was suddenly drafted for military duty, despatched to his native Algeria, and hospitalised two weeks later with depression. At the same time, several of Yves' clients – devoted patrons of the house of Dior – found themselves out of step with his youthful direction, and in hospital he learned he had been fired. Transferred to Val-de-Grâce military hospital in Paris, things got even worse for Yves. His treatment was grim, and it took Bergé many weeks to rescue him. It was at this low ebb that Yves and Pierre felt the glimmer of possibility: they would build their own maison de couture to rival Dior and even follow Yves' hunch to expand into ready-to-wear.

First up, Yves filed a suit against his onetime employer for breach of contract – and won! The funds were used to create the first Yves Saint Laurent haute couture collection, debuting in Paris on 29 January, 1962. Reviews were generous, if mixed, but most of the guests seemed impressed with the mere fact that Yves (and Pierre) had pulled off such a feat. There was a day dress, for instance, with a crisp, tiered layered skirt and unexpectedly slouchy silhouette that suggested both fun and formality. Patricia Peterson, fashion editor of *The New York Times*, noted Yves' maturity: 'St-Laurent has grown up, and so have his clothes', she wrote, adding that he might turn out to be 'a shot in the arm to the Paris couture'.

Yves and Pierre's audacious move certainly ruffled a few marabou feathers. Later that year, Dior filed its own suit against Yves and Pierre, upset that its own artisans were leaving in droves to join maison YSL. Pierre said the complaint was like 'something out of a bad novel', and the battle lines were drawn.

THE TRENCH COAT

1962

Just like his preoccupation with men's military classic the Pea coat, Yves used his debut haute couture collection to feature another icon of outerwear: the Trench. Originally created for British Army officers in the First World War, Yves gave it a female silhouette and cropped it at the hem, raising it to a thigh skimmer, but changed little of the trench coat's traditional details. He kept its raglan sleeves with seams that travel diagonally up to the neck and its double-breasted cut with two rows of buttons, and sent it out with his luxurious couture creations.

Although his debut collection was thrillingly anticipated, it wasn't quite the slam dunk success both Yves and Pierre had hoped. In her deliciously gossipy book *The Beautiful Fall: Fashion, Genius and Glorious Excess in 1970s Paris*, author Alicia Drake notes that when Yves first joined Dior, the couture client 'was not a woman, but a lady – preferably titled and chauffeur-driven,' and 'one of the gracious few.' In founding his own maison and letting his inner creative spirit shine, Yves seemed hesitant to evolve his customer and offer something truly radical. So, there were silk brocade 'Raj' coats, cute cocktail dresses and 'arms trapped in long satin gloves,' writes Drake. In other words, nothing to scare the horses. It was the Trench and the Pea coat that really stood out; both seemed to be inspired by the rather cool Beatnik subculture and hardwired into Yves' youthful creative force. The Trench fast became a core YSL piece, returned to collection after collection, like this metallic gold version from Yves Saint Laurent haute couture Winter 1980–81. Of course, the Trench is now a staple womenswear piece, but back in 1962 it was just surprising enough to mark out Yves as a designer from whom fascinating things were to come.

YSL WOMEN

ANNE-MARIE MUÑOZ

Yves forever friendship with Anne-Marie Muñoz (1932–2020) was forged over the pin-littered floor of Christian Dior's back rooms in 1951. Muñoz went on to become Yves' haute couture studio manager in 1963 and stayed by his side until the studio closed four decades later. Happiest out of the limelight, it is easy to underestimate Muñoz's part in building the great fashion house – almost her entire career was devoted to Yves Saint Laurent, and she was integral in helping shepherd the fashion house through the sixties to become the world's most adored and influential haute couture house in the 1970s and beyond.

After Muñoz's death at the age of 87, Dominique Deroche, one-time press officer of the house, described her as '… a pillar for Mr Saint Laurent', to French newspaper *Le Figaro*. 'She was a very rigorous personality for whom we had a deep admiration. She chose the fabrics, met the young designers and played the diplomat when there were crises.'

Muñoz was one of the final witnesses to the birth, and golden age, of couture, and Yves thought of her as his sister – or so the legend goes. And, although her heart belonged to Yves, she was a beloved figure in haute couture land, and even made Karl Lagerfeld the godfather to her son, the photographer Carlos Muñoz. Anne-Marie Muñoz died in 2020, and in October 2023, Saint Laurent announced a new handbag, Le Anne-Marie; a vintage-seeming leather clutch with kiss-clasp, shoulder strap and embossing – small and stately – likely inspired by Yves' beloved studio manager herself.

THE FIRST PEA COAT

1962

Yves loved to rummage. In the early days of the brand (and forever after), the designer's travels often included trips to unsuspecting army surplus stores where he would ferret out garments, including fun outfits to wear with friends at weekends. So much of his inspiration came from these shopping trips, fusing military classics and menswear tailoring with the YSL DNA.

Take the Pea coat, the iconic thick wool, double-breasted and slightly cropped overcoat originally worn by sailors. It had acquired a little Beatnik cool throughout the late 1950s and '60s and had already been worn by James Dean and, later, Bob Dylan. In 1962, he took its simple, masculine shape, recrafted the silhouette, and somehow made it couture. It was a startling move: a practical garment for men delivered to female haute couture clients. It shouldn't have worked, but it did. 'The fact that it was not fitted and covered the hips', writes the Musée YSL in Paris, 'made it ideal for women who did not yet feel daring enough to wear pants.'

Yves was so confident in his creation, he opened his own debut show with it in 1962. The first YSL Pea coat was worn with white shantung pants and mules – and it was a moment. The unique look became Yves Saint Laurent's truly signature style, and its popularity encouraged Yves to delve further into his own menswear wardrobe for inspiration.

ROBIN HOOD INSPIRATION

1963

After his leather jacket disaster at Dior, Yves might never have used the material again, but this was *his* maison de couture, and his own rules. For the Yves Saint Laurent haute couture Autumn/Winter collection in 1963 he drew from the English folk hero Robin Hood, and put swaths of leather, oilskin and crocodile on the runway, including this daytime look. He sent out this tunic, rendered in suede with military patch pockets and contrast suede cap with a pair of eyebrow-raising thigh-highs.

Ignoring the uneasiness surrounding Yves' inspiration (the legend of Robin Hood is one of anti-capitalism and the elite getting their comeuppance; hardly a couture fan's heartthrob), the look was a success, and Yves was a welcome star returning to the scene. Back then, 'The press fell upon his every collection, delighted to have found a successor to the seventy-something-year-old generation of Balenciaga and Chanel', writes Alicia Drake in The Beautiful Fall, 'but more significantly, delighted to have found the Parisian rival to London's growing phenomenon of youthful fashion stars such as Mary Quant and Ossie Clark. He did tweedy Robin Hood suits with shorts that he put with brown suede thigh boots.' For Brits, Robin Hood has an undeniable link to pantomime, a low-brow theatrical obsession, and Yves' collection might have looked just as at home on stage at the Hackney Empire as it would on the trendy King's Road, but as Drake reminds us, '... it seemed no one could resist Yves'.

CHAPTER 2

CREATING THE SIXTIES

1963–69

CLAUDIA CARDINALE IN *THE PINK PANTHER*

1963

Claudia Cardinale (born 1938) won the 'Most Beautiful Italian Girl in Tunisia' competition in 1957 and became the 'transcendent muse' in Federico Fellini's 8½, according to film curator Kate MacKay. Her 'performances are imbued with an intelligence and depth that surpass the confines of the scripted characters'. Comic caper *The Pink Panther* (1963) might not be Fellini (the reviews are ... fine), but Cardinale looks quite incredible in it. Just one year into founding his own maison de couture, Yves Saint Laurent was commissioned to create costumes for the Panther's leading ladies.

Yves dresses Cardinale who plays Dala, a princess on the run (and her co-star, Capucine), in elegant cocktail dresses, bejewelled ball gowns and super cool après-ski looks with classic YSL cigarette pants and some high-wattage headwear. *Vogue* notes Yves' outfits for *The Pink Panther* are the ultimate in cinematic 'swanky ski style', where 'swaths of fur trim their coats', and their 'layers look anything but bulky'. Dala/Cardinale's luxuriously beaded, tangerine-toned tunic gown is an Yves-made wonder; the actress wore it in the film's promotional imagery, and Yves' sketches of the piece can be seen in Musée YSL's digital archive; Cardinale is the jewel of the film.

Y: THE FIRST FRAGRANCE

1964

In 1964, following in the footsteps of other maisons de couture in Paris, the house of Yves Saint Laurent launched its first fragrance. Y – pronounced i-grec – which arrived first in Europe and reached US shores in October that year. The original Y is thought of as a chypre, a genre of fragrance with citrus top notes, and YSL describes Y's three main spheres as 'galbanum, ylang ylang and oakmoss'. Although reporters sniffed 'green, fresh and different', according to *The New York Times*, it was nevertheless a hit.

Y was delivered in small rectangular bottles inside painfully chic white boxes bearing the intertwined serif lettering of the now iconic YSL monogram. For the latter design, Yves had tipped the great A. M. Cassandre (Adolphe Jean-Marie Mouron) for the job. According to the French branding agency Graphéine, the three overlapping initials comprise 'a very vertical, lively design, in which the elegance and modernity of Saint Laurent are perfectly combined', and it was the 'one and only proposal made by Cassandre to Yves Saint Laurent and Pierre Bergé during a meeting in a Parisian restaurant'. He was probably the world's coolest graphic designer and typesetter at the time, and he was commissioned on the spot.

As one of the 'musketeers of graphic design' along with contemporaries Jean Carlu, Paul Colin and Charles Loupot, Cassandre's personal style was a kind of futuristic Art Nouveau. With this fusion of old and new, the artist ensured the monogram's longevity. Graphéine reports Cassandre said it was 'designed to age at the same pace as the stones on Avenue Marceau' (the street where the Musée YSL Paris is located today).

THE MONDRIAN DRESS

1965

'I hate Mondrian now', quipped a young Yves to *The New York Times'* Angela Taylor in November 1965. His three-week trip to the US, peppered with '30 or 40' parties (there had been so many, Yves was unsure), allowed him to spot his famous dress inspired by Dutch interwar artist Piet Mondrian everywhere across town – and all of them copies. Every department store window display and fashion boutique seemed to house inexpensive versions of the designer's must-have dress and Yves was simply *over it*. At least the 'numberless cheap copies' reminded Yves to visit the Museum of Modern Art to see a selection of Piet Mondrian pieces in real life; he even called the Dutch painter the 'father of my dresses'. But why was this seemingly simple, painterly dress turning everyone's heads?

Weeks earlier, in anticipation of his almost-royal visit, the same newspaper noted that Yves had the 'knack of bringing out the sheep instinct in women', with Marylin Bender writing that his Mondrian dress had been 'seized by toddlers and grandmothers alike', alluding to the confident simplicity of one of Yves' (and Mondrian's) greatest creations. This is partly why the Mondrian dresses were such a showstopper. Yves' series of cocktail dresses – simple jersey shifts, daring in their directness – with Mondrian's coloured blocks and black frame details sewn and seamed into the garment, were the centrepiece of his Autumn/Winter 1965 haute couture collection. Yves chose works from Mondrian's mid-war years but, when he stitched them into life, the designs felt wholly modern. In the end, 26 of Yves' 106-piece collection were Mondrian-inspired, but the bold move wasn't a gimmick: it signalled Yves' growing signature: refined simplicity through startlingly skilful design, movement and modernity.

"

WHEN I WAS YOUNG IN THE 1960S, ALL THE WORLD WATCHED THE YOUTH. EVERYWHERE WAS THE SENSATION OF WANTING TO BREAK THE CHAINS BUT TO DO SOMETHING BEAUTIFUL.

Yves Saint Laurent

"

THE KNITTED BRIDAL GOWN
1965

With guests fizzing with the excitement of seeing Yves Saint Laurent's Mondrian dresses for the very first time, a playful, upbeat mood was set at YSL's Autumn/Winter haute couture presentation in 1965. Then came Yves' showpiece, an unforgettable bridal gown to close that season's show. It was a couture tradition to end with a ravishing bridal look, but this was no voluminous meringue fantasy or slinky slip dress. Instead, Yves sent a hand-knit wool cocoon with ivory silk satin ribbons hobbling down the runway. To some, it was a living Russian matryoshka, to others, a depiction of Artemis or Diana – or even an oversized Versailles wig in off-white yarn, with the model's face peering nervously out of a porthole. Whatever it was, the audience went wild.

In recent years, *Vogue* named Yves' matryoshka 'one of the most OTT couture brides ever' and the piece has indeed become an essential part of YSL lore. The dress appeared again at Yves' final couture show in 2002; it pops up periodically on knitting and crochet forums (of course) and has been recreated using hundreds of condoms by French drag performer, La Grande Dame. It has even inspired contemporary designers: US *Vogue*'s Sarah Mower has noted its influence on the work of British designer Richard Quinn, inaugural winner of the Queen Elizabeth II Award for British Design, who is fascinated by the golden age of couture. In 1965, Yves' show guests could not have guessed how influential – or maybe just unforgettable – this knitted dress would become. Wool, for a winter wedding? Groundbreaking.

LE SMOKING
1966

It is cigar-smoking, celesbian actress and Hollywood golden age icon Marlene Dietrich we have to thank – in part – for one of Yves Saint Laurent's signature looks: the sublime and slim-cut women's tuxedo known as Le Smoking. 'I was deeply struck by a photograph of Marlene Dietrich wearing men's clothes', said the designer. 'A tuxedo, a blazer or a naval officer's uniform – a woman dressed as a man must be at the height of femininity to fight against a costume that isn't hers.' He went on to create his own version; previously worn by men to protect their clothes in the cigar and pipe smoke-filled chambers of gentlemen's clubs, but now it was the turn of Yves' women.

Of course, a woman doesn't need to be 'feminine' to wear just about anything, but Yves was designing in the 1960s, the era of second-wave feminism and the Women's Liberation Movement and was fascinated by Dietrich, whose gender-bending dress sense was honed decades earlier in the 1930s; both were ahead of their time. In fact, Saint Laurent was so far ahead, his haute couture clientele – moneyed, traditional and a little dusty – struggled to keep up with him. The reception to his 1966 haute couture collection, just a year after his celebrated Mondrian dresses, was lip-bitingly tense: trousers? *For women?* Had the young designer gone mad? Only one pair was sold. But the Yves Saint Laurent juggernaut was already thundering *sur la rue* and, weeks later, his ready-to-wear boutique opened on Paris's Rue de Tournon on the Left Bank (a place of burgeoning cool). Here he unveiled his new affordable Yves Saint Laurent Rive Gauche line, with a new version of Le Smoking as its centrepiece. The tux was a hit with Yves' new-found younger and hip audience and Le Smoking's spark was lit.

YSL WOMEN

DANIELLE LUQUET DE SAINT GERMAIN

When Danielle Luquet de Saint Germain was just 19, she waltzed into a YSL model casting in Paris wearing her most intriguing outfit. Her men's trench coat and trousers made for a memorable look and Yves' interest – already fascinated by how men's tailoring and military wear could be used in couture – was piqued. Luquet soon became a house model at Saint Laurent, a living, breathing collaborator on which Yves could try out his designs. She came to represent a 'sexualised, modern '60s woman that was very, very different to the mannequins [Yves had] been working with at Dior', explains fashion journalist Hamish Bowles in his video series, *Vintage Bowles*.

It was on Luquet that Yves fitted his first tuxedo-inspired Le Smoking look and his iconic safari jacket, and with whom he scandalised the fashion world by dressing her in a series of completely sheer pieces – sans brassiere. For Yves Saint Laurent's Autumn/Winter 1968 haute couture collection, Luquet wore both a sheer full-length dress, black and embellished with ostrich feathers around the waist, and this blouse with a long mermaid skirt, cinched with a high-gloss bow – her bare breasts completely on show. Bowles points out how shocking this would have been at the time: 'inured as we are to transparency on the runway, I think it would be a little bit startling today.' Bowles is right, but that hasn't stopped Yves' Nude Look becoming a touchstone for the other YSL designers that followed, right up to current Creative Director, Anthony Vaccarello. Luquet eventually drifted from Yves' orbit but worked with several other Parisian couturiers. In 2013, she auctioned off an incredible collection of 12,000 couture pieces, from YSL to Lacroix, with auction house Georges Delettrez.

YSL ON SCREEN

CATHERINE DENEUVE IN *BELLE DE JOUR*

1967

Even by the earliest days of the brand, Yves had a history of dressing performers – forever linking the great fashion house with cinema. In 1966, he stepped in to dress Catherine Deneuve for *Belle de Jour* (1967), director Luis Buñuel's beloved (and hard to watch) masochist masterpiece. Yves and Deneuve had met the year before: the 22-year-old actress, then married to photographer David Bailey, had asked Yves to dress her for a meeting with Queen Elizabeth II. It was a success; soon Yves was dressing Deneuve for many of her appearances.

In the movie, Deneuve plays Séverine, a beautiful (of course) but thoroughly bored Parisian housewife whose buttoned-up nights at home with her husband contrast with her days, when she transforms into Belle de Jour, a high-class prostitute. It was Saint Laurent's first project with Deneuve and he excelled at the brief: all bridled yet chic conservatism in Séverine scenes – a white tennis outfit and peach-coloured, buttoned-up cardigan for example – and for Belle? A scarlet double-breasted jacket, a khaki, gold-belted safari dress for a trip to a brothel and lascivious BDSM in black vinyl, tailored, military-like and fetishistic, with sunglasses. Cinema legend has it that Yves would spend long hours on set, hanging out with Deneuve, and the young actress asked to have Séverine's outfits shortened to be more in keeping with the mini skirt trend of the time. Yves, apparently, persuaded Deneuve and Buñuel to veer away from trends, and it's true that *Belle de Jour* is often noted for its considered and timeless look. Deneuve and Yves were friends for decades, and in 2002 she closed his last runway show, held at the Pompidou Centre, singing, 'Ma plus belle histoire d'amour' with Laetitia Casta.

THE SAHARIENNE

1968

The Safari jacket – part of Yves Saint Laurent's design DNA – drove fashion fans wild on its debut in 1967. But the Saharienne, aka the house's iconic safari jacket, was almost an afterthought: Yves had created the piece for a shoot for *Vogue* (Paris) and was minded to add it also to his runway collection. The jacket – delicate, tailored and, *whisper it*, fun – was a spin on a classic utilitarian safari jacket, itself inspired, in part, by the Afrika Korps uniform. It was rendered in a cool gabardine cotton with epaulettes and patch pockets just about everywhere. When Yves' issue of *Vogue* starring the Saharienne hit newsstands the following year, the fashion press had already declared it a design masterpiece.

Much like Le Smoking, Yves' women's tuxedo, the Saharienne borrowed from classic menswear, only this time with a less luxurious, more utilitarian, military feel. On a trip to New York City in 1965, he told Angela Taylor at *The New York Times* that, for all the parties and happenings he had attended during his time there, he was most interested in visiting an Army Navy surplus store he had heard about from an American friend to 'buy silly things for myself, for weekends'. (The idea of the late, great designer going from dancefloor to the dusty shelves of thrift stores and army surplus outlets is charming.) Today, original Saharienne pieces auctioned-off from Yves' first few collections look startling contemporary. Their overall simplicity, lightweight fabric, and minimal embellishments make them as timeless as their classic utilitarian inspiration.

YSL WOMEN

BETTY CATROUX

At the opening of London's first Rive Gauche boutique on Bond Street, London in 1969, the fashion press thought they were seeing double. There was the 31-year-old Saint Laurent himself, handsome, long-haired and impossibly leggy, in his own men's safari jacket and chinos and his signature sunglasses – and by his side was his 'twin', the equally handsome, long-haired and impossibly leggy Betty Catroux (born 1945) in a matching outfit. It wasn't the first time the great pals had dressed alike: it was their party trick for fashion parties and events where they loved to make a splash before running off together; Yves and Betty were inseparable.

Although they spoke most days on the phone, and Catroux was at Yves' side for decades in Paris, London, Morocco, and finally, at his bedside as he passed away in 2008, in every interview, the Brazil-born icon disputes the term 'muse'. The Saint Laurent designers disagree: Tom Ford dedicated his first Saint Laurent Rive Gauche collection to her, and current house head Anthony Vaccarello told the Musée YSL, 'everything that makes up the house's aura – an allure, a mystique, an almost scandalous aspect, an elusive yet enticing brush with danger – finds its powerful expression in Betty.'

Catroux is often asked about her time at the top of the haute couture fashion heap, but 'I am not at all nostalgic of the past', she admitted to *The New York Times* in 2020, whereas 'Yves always thought things were better before, but I love to live with my times'. Proving her point, in 2018, she rid herself of 180 YSL haute couture creations and accessories, and 138 ready-to-wear creations, donating them to Yves' and Pierre Bergé's foundation. *Au revoir*, fashion!

THE FIRST JUMPSUIT

1968

Spring/Summer 1968 saw Yves introduce the jumpsuit, now an iconic Saint Laurent garment. Following Yves' fascination with menswear and military garb, his jumpsuit was a reworking of the functional garment worn by aviators. Unlike the male original, Yves' version was cinched, showing off the wearer's curves. At least one version was rendered in Yves' Nude Look with black chiffon that left little to the imagination; this black crepe version is startling in its simplicity with a sexy slashed front and necktie (which looks like it could become unknotted at any moment).

By the Autumn/Winter collection, Yves had turned to black. 'Yves Saint Laurent is mourning over Vietnam,' wrote *The Observer*, 'and the first public showing of his eagerly awaited Autumn collection on Monday will read as one big, all black, Vietnam protest.' The mood had changed, and Yves' jumpsuits were now 'businesslike jersey boiler suits sometimes worn with tunic-length jackets, often with a high, side-fastening collar … skinny to the hip, then flared'. The gloomy collection was a hint, perhaps, at Yves' changeable mood and how his own cultural barometer influenced his designs. He even gave a startling quote that seemed to proclaim the death of couture: a shocking viewpoint from the little prince of couture himself. 'First nights at the theatre … life on a yacht, things like that belong to a society which no longer means anything', he said, nihilistically, '… Social ladies are no longer significant'. Buyers crossed their fingers that whimsy, sexiness and colour would soon return.

ART OF FASHION

1969

Yves met the artist Claude Lalanne (1924–2019) through her husband, a young dress designer at Dior called François-Xavier Lalanne. Together, Claude and François-Xavier, aka Les Lalanne, undertook eccentric art projects and private commissions. They created bespoke interior pieces and whimsical furniture – from chairs that looked like sheep to Claude's metallic cabbage-headed man (a piece loved by Serge Gainsbourg that even appeared on one of his album covers). But it was Claude's solo work that earned her a place in the Yves Saint Laurent Autumn/Winter 1969 haute couture collection. The artist made casts of the model Veruschka's chest, stomach and even fingertips to create a sort of fashion armour, rendered from lightweight metal and electroplated with copper (electroplating was Claude's go-to technique, something she honed over a lifetime and was still in the thick of in her early 90s, reported *The New York Times* on her death in 2019). This Evening Ensemble in flowing chiffon is adorned with a waist sculpture by Claude Lalanne; the piece was worn on top of the ensemble in an exciting, slightly jarring contrast.

YSL ON SCREEN

CATHERINE DENEUVE IN *MISSISSIPPI MERMAID*

1969

In his erotic thriller, *Mississippi Mermaid* (1969), director François Truffaut channels Hitchcock, making Catherine Deneuve his icy blonde femme fatale. Friends with Yves Saint Laurent since she campaigned for him to dress her in *Belle du Jour* (1967), Deneuve wears YSL again in *Mermaid*, making her one of cinema's chicest tricksters, fleecing Jean-Paul Belmondo of his fortune and breaking his heart in the process. Her outfits are from YSL's iconic Rive Gauche Spring/Summer 1968 collection, the one that launched Yves' classic gabardine safari jacket. Collaborating on Truffaut's racy film (yes, there are boobs) was a smart move: it was yet another shop window into the YSL world, and Deneuve was its celebrity mannequin.

The film itself, visually stunning and painfully cool, is typically Truffaut (and was remade as steamy thriller *Original Sin* in 2001 with Angelina Jolie and Antonio Banderas), who, it seems, was a fashion fan himself. 'Of all the major couturiers, [Yves] is the biggest cinephile', said Truffaut, as reported by the Musée YSL Paris. A scene where Deneuve is spotlit with cigarette in hand, a cloud of smoke suspended above her, wearing Yves' barely-there sequinned bodysuit, cut almost to the navel and glistening like fish scales, has a particularly powerful erotic magic.

CHAPTER 3

DEFINING FASHION

1969
–80

THE SCANDAL COLLECTION

1971

'Yves Saint Laurent's 1971 collection was frequently denigrated as "tarty", and the models were compared to 1940s streetwalkers', opined *The New York Times* in 2017. It's true there's a certain Second World War wantonness to this short evening ensemble with its almost-camouflage print and slinky fox furs. In fact, the whole haute couture Spring/Summer collection went heavy on swathed hips and saucy cutout bodices, but Yves was having none of it. He called his critics 'petty, narrow-minded reactionaries', in that same newspaper in 1971 (Yves loved to snap back at his detractors, it certainly gained him column inches).

His constant criticisms of haute couture and its inherent stuffiness made it seem as though Yves' maison was the only place to discover true creativity. But at the same time, to reporters, he would threaten to give it all up to focus solely on his youth-oriented ready-to-wear Rive Gauche brand. In truth, it was another 31 years until Yves decided to end his couture line, but in 1971 it all made for a lot of reactionary heat and noise. Looking back, Yves' collection and its 'tarty' quality was more influential than its critics could ever imagine. It seemed to predict the wafty, sexier looks of the 1970s, which drew on elements of 1940s retro style, and Yves was the first to do it. It became known as the Scandal collection, but that seemed to excite Yves. 'I also am very stimulated by this scandal', he said at the time, 'because I know that which shocks is new.'

ROMY SCHNEIDER IN *MAX & THE JUNKMEN*

1971

Claude Sautet's gritty crime drama *Max et les Ferrailleurs* (1971) sees Max, an uptight and unlikeable cop, go undercover to entrap a gang of low-level scrap thieves. But he gets in too deep and falls for the boss's gorgeous love interest, played by Romy Schneider, whom Max just can't stop looking at through his camera lens. At the time, Schneider was one of the most celebrated performers in France, her celebrity relationship with Alain Delon had ended a few years earlier, and everyone wanted to work with her, including self-confessed cinephile, Yves.

One of five Claude Sautet films Romy starred in throughout the 1970s, playing a prostitute in *Max* seemed to be yet another way for her to throw off her vanilla reputation (she was a star of sickly romance movies in the '50s). Film lecturer and writer José Arroyo notes, 'Sautet gives Romy Schneider a fabulous star entrance' as she walks onto the screen, as seen through Max's lens. 'A ribbon around her neck [is] tied into a jauntily-angled bow', which, as Arroyo points out, 'is Romy's signature look for this film', but her 'high-heeled ankle-strapped shoes, and a shiny black vinyl raincoat' are pure Yves Saint Laurent. Tipping it as one of the 'most stylish Saint Laurent looks on film', *Vogue* reports Romy's outfits are 'sumptuous, structured, sexy and designed to be worn while wafting through crowded parties with a cigarette holder in hand.'

GREEN FOX FUR

1971

The unlikely star of YSL's 'tarty' but undeniably influential 1971 haute couture Spring/Summer collection, also known as the Scandal collection, is this mid-length fox fur coat in a shaggy style affectionately known as a 'chubby'. With football player shoulders and an unforgettable lurid hue, it has the look of a garish green fluff monster.

It's fair to say that Yves' 1971 Spring/Summer collection bombed. But what was thought of as bad taste at the time, creating an atmosphere of both excitement and angst for Yves, was thoroughly (and rightfully) celebrated at Yves Saint Laurent's barnstorming final show in 2002. The decades had been kind to this iconic piece, and it was one of the most memorable aspects of Yves' epic presentation. There, in front of 2000 attendees at the Pompidou Centre (with thousands outside, watching on a big screen), Naomi Campbell slinked down the runway in sheer tights, black heels, Yves' scandalous poison-green foxy coat and little else; she was the moment. Later, the scandal took another form: it was another 20 years before Saint Laurent scaled down and eventually stopped using fur, with its parent company going fur-free in 2022.

YSL INSPIRATIONS

JARDIN MAJORELLE

Ask for the 'Saint Laurent Garden' in Marrakech and you'll find yourself directed to the breathtaking Jardin Majorelle. It's the most famous garden north of the Sahara and was once the home – and grand design – of artist Jacques Majorelle. The series of desert gardens, pools and fountains at the foot of a Cubist villa designed by Paul Sinoir are suffused in Majorelle blue. The distinct, unbelievably bright and impossibly cheering colour is everywhere and was patented by Jacques, who was inspired by the vibrant Islamic art he saw all around him. No wonder Yves and Pierre fell in love with the place.

Yves and Pierre had been visiting Morocco since the mid-60s. 'In 1966 our idea was simply to spend a month at the Mamounia [hotel]', Pierre told the BBC in 2016. 'But we saw that Marrakech was a wonderful city and we decided to buy a property there. For the first 10 years we had a tiny house in the medina, the Arabic quarter. We loved the house.' With the Majorelle close by, on hearing it was about to be redeveloped, the Parisian pair purchased both the Jardin and Cubist villa in 1980 and set about restoring and improving the site. The site now houses a memorial to Yves, a museum dedicated to Berber art, with a much larger Musée Yves Saint Laurent Marrakech nearby. 'When Yves and I were [in Marrakech] it was fantastic,' said Pierre in his BBC interview, 'we were young and to be young is a wonderful time.'

> I LOVE BLACK BECAUSE IT AFFIRMS, DESIGNS AND STYLES. A WOMAN IN A BLACK DRESS IS A PENCIL STROKE.

Yves Saint Laurent

YSL OBJECTS

OPIUM

1977

Incredibly sexy, irresistible and intoxicating, YSL's Opium launched in 1977 to excitement and endless controversy. Yves had strong commercial instincts, even if his couturier peers (and some of his clients) frowned upon his fascination with cash-strapped youth. But couture was simply out of reach for most, so Yves pushed forward with cheaper ready-to-wear lines, all the while keeping a buzz going in the press, while other couturiers lagged snobbishly behind. Fragrances were the perfectly priced entry point into the house of Yves Saint Laurent and Yves had decided to make the most it.

Opium was a labour of love. Yves was deeply involved in the fragrance, from its heady formulation (patchouli, myrrh and vanilla) to its tasselled lacquered-red bottle and packaging; its commercials (Jerry Hall photographed by Helmut Newton, natch); and even the info pack given out to journalists. The fragrance ran into trouble in the US with accusations that the name Opium and the ad campaign promoted drug use, but the scandal did wonders for the maison. Perhaps Yves anticipated all the lip-biting nervousness in the press and was excited by it? Either way, it was a hit! Stocks kept selling out, and in just 12 months European sales hit $30,000,000 – previously unheard of. Over the years, Opium has continued to cause a stir, from accusations of cultural insensitivity to lascivious marketing. In 2000, an Opium campaign image featuring Sophie Dahl, naked but for a pair of stilettos and apparently high as a kite, was removed from outdoor billboards in the UK so as not to distract motorists (but won an award in Spain).

OPIUM
parfum

Yves Saint Laurent

YSL INSPIRATIONS

FRIENDS IN MOROCCO

In 2014, just three years before his death, Pierre Bergé was in a contemplative mood. He published a beautiful memoir, *A Moroccan Passion*, a gorgeous book using a handwritten font and watercolours to memorialise some of the happiest times in his life: endless summers spent with Yves and friends in Morocco. The pair first vacationed there in 1966, and bought a house there. The art and culture of Morocco became a lifelong love and influence on both men, on YSL the brand, and on visiting friends like Loulou de La Falaise, Andy Warhol and Betty Catroux.

Outside of Pierre's memoir, the descriptions of others make these summers sound more like a sexy summer camp. 'For Yves those first years in Marrakech were his happiest', writes Alicia Drake in *The Beautiful Fall*. 'There were picnics in apricot groves and the sound of Verdi in orange-blossom courtyards. There were sexual encounters and trays of kif [cannabis] brought in by a manservant in the evening candlelight. It was a hidden life behind closed doors.'

The Islamic country, liberated from colonial France in the 1950s, has an uneasy relationship with Western liberalism. While wealthy, arty types like Yves, Pierre and their friends have often found a home there over the decades, and Marrakech continues to have its own artistic community, Morocco criminalises homosexual acts, and there is evidence this has been increasingly enforced in recent years. The Musée Yves Saint Laurent Marrakech, opened by Pierre in 2017, is a testament to the man he loved, even if that love was – and is – forbidden.

A DREAM OF SPAIN

1977

'Saint Laurent is the only couturier these days who finds it necessary to take his clothes out of the salon and into a much bigger place,' wrote fashion critic Bernadine Morris in *The New York Times*, 'because he has so many admirers, you see.' She had attended Yves' Spring/Summer 1977 show at the Hôtel Grillon in Paris and noted the large audience and starry guests. But what of Yves' collection, Les Espagnoles et les Romantiques, his personal dream of Spain with its flouncy skirts, fringed shawls and velvet corsets? 'Rich women in peasant garb, liberated by Saint Laurent', said Morris, flatly. Yves hated to travel (unless to Marrakech) and would instead create his own imaginary versions of faraway lands. This collection seemed to stray into theatrical costume, but Morris found it hard to dismiss Yves' less obvious but lovable details: an almost Victorian 'high-standing collar' on a blouse that became an influential trend in seasons to come, the ruffles and endless polka dots.

The press loved to write about the feverish celebrity that surrounded Yves, forgetting they had played a part in his legendary success. Morris was wowed by the reception to Yves' flouncy Spanish dream ('but the applause!'), but what might have appeared strained in the hands of other couturiers was a delight in Yves'. 'The amazing thing is that he makes it seem all quite amusing', she wrote.

YSL WOMEN

MOUNIA OROSEMANE

Thought of as one of the world's first Black haute couture models, fine artist and musician Mounia Orosemane, born in Martinique, was a favourite of Yves Saint Laurent and first appeared for the house in Yves' 1978 haute couture show (said to be both inspired by the opera *Porgy & Bess* and Mounia herself). Apparently 'discovered' by Hubert de Givenchy and Cacharel's Jean Bousquet, Mounia left Martinique airport, where she worked as an announcer, and headed to the French capital. Her first appearance was on the runway for Givenchy in 1976, but Mounia soon gravitated towards Yves and became one of his favourite models, dominating the catwalks of the early 1980s in both YSL shows and for Karl Lagerfeld, Thierry Mugler and Gianni Versace.

Bernadine Morris was at Yves Saint Laurent's 1981 Autumn/Winter show for *The New York Times*, and noted the fizzing energy around the designer and model. She reported: 'the model Mounia, the designer's favourite, carried red roses and wore a jewelled crown. She was attended by a page and a flower girl in wine velvet … Mounia kept her poise and her balance when the children stepped on her long black tulle veil … when the model reached the center, Saint Laurent, in a light gray suit, strode out to meet her.' It wasn't even the show's finale but, 'the photographers went wild,' writes Morris, 'interrupting the procession.'

YSL INSPIRATIONS

LE PALACE, LEGENDARY NIGHTCLUB

1978

In the late 1970s, Paris remained the cool capital of the world, but its top spot position was about to be challenged. With fashion and nightlife thriving in Milan, London and New York breathing down their necks, the Paris elite had something to worry about. In *The Beautiful Fall*, fashion journalist Alicia Drake reveals that, when news of the Italians' growing prowess in fashion reached Pierre Bergé, he 'snorted with derision and replied, "Italians don't make fashion, Italians make spaghetti!"'

After night club Studio 54 had opened in NYC in 1977, Paris refused to be outdone. A megaclub to rule them all, Le Palace opened in March 1978 with Grace Jones singing 'La Vie en Rose'; 'life seemed so rosy-hued that even the coke had turned a shade of pale pink', writes Drake. Yves, his muse and 'twin' Loulou de la Falaise and the wider YSL crew were at the centre of Parisian society, and while they might start the evening with sprawling private dinners, they would always end up going wild at Le Palace. Images of Yves at Le Palace's infamous costume parties, surrounded by his friends, are a thrilling document to a city that held on to its cool status with a firm grip.

THE BROADWAY SUIT

1978

For haute couture Spring/Summer 1978, Yves was inspired by George Gershwin's iconic opera, *Porgy & Bess*, the 'elegant women of Harlem dressed in their Sunday best', (according to the Museé YSL Paris), and Yves' favourite model at the time, Mounia. He dressed Mounia in a series of short, mannish spencer jackets – traditionally cropped smart workwear garments – and louche, loosely tailored suits with cropped trousers dominated the show. The spencer jacket seemed to rival the bolero for an eveningwear piece, and Yves sent one down the catwalk with a just a lace bra underneath. Later, Yves' rival, Karl Lagerfeld, let it be known that he had done spencer jackets two seasons before, but clearly his version hadn't sparked interest; Yves' version was on fire.

This wild runway presentation of the 'Broadway Suit' collection had all 'the fervour of a revival meeting', wrote *The New York Times'* Bernadine Morris. Yves was at the height of his fame; the atmosphere was near-insane, and Morris *could not even* with the amount of possibly sycophantic applause each look received. 'The Master could have wrapped a telephone book around a model', she wrote, 'and he would have started a trend.'

HIGH SEAS CHIC

1978

For his High Seas Chic ready-to-wear Spring/Summer 1978 collection, Yves Saint Laurent put up chiffon tiered dresses, like this tri-colour pleated look worn by his muse and mannequin, Mounia Orosemane. It was an easy, upbeat collection that failed to excite the critics but did well in store.

But for all the fun and nautical exuberance of High Seas Chic, all was not well with Yves, then 42 years old. Victoire, once his favoured muse and mannequin, reunited with Yves after many years backstage at Pierre Bergé's newly acquired theatre during a production of *L'Aigle à deux têtes* (Yves designed the costumes and sets); she later told French lifestyle magazine *Paris Match*, 'There he was, sitting all alone at a table, his head in his hands. He was a broken man.' He apparently told Victoire that, at his worst, he drank four litres of pastis and smoked 120 cigarettes a day. By that time, Yves and Pierre were living apart, and more of their growing empire – the maison and its four collections a year, its fragrances and jewellery, its boutiques, real estate around the world and hundreds of jobs – relied completely on Yves' design genius and work ethic. The pressure was immense.

JERRY HALL, GOT IT ALL

1980

What started with Piet Mondrian in 1965 continued with other artists throughout Yves' career as a couturier. Paying homage to Henri Matisse, Vincent van Gogh and others in his collections, Yves Saint Laurent tapped Pablo Picasso in 1980. For haute couture Autumn/Winter 1979–80, he drew on the work of the great artist who had died a few years earlier. As fashion's greatest showman, Yves sent out 267 pieces onto the runway (at least 100 more than most) including knee pants, bloomers of every length, harem pants and flouncy skirts in joyful tones. Some noted a few 'fancy dress styles in the show, such as ... some tutus with trains', wrote The New York Times' Bernadine Morris, like this racy look worn by Jerry Hall.

Yves had already been inspired by another Picasso: his friend and muse Paloma Picasso, daughter of Pablo. Her interest in vintage clothing is thought to have influenced Yves' retro-edged Scandal collection in 1971. At the show in 1979, based on her father's harlequin period, Paloma sat 'by the designer's side for a time after the show, beaming', wrote Morris.

KIRAT YOUNG

Kirat Young, the first Indian supermodel, went to boarding school in the Himalayas, studied fashion in London and was introduced to Yves Saint Laurent on a trip to Paris in 1976. 'He was designing his Ballet Russes collection,' she said in *The New York Times* in 2016, 'It was exotic, and I fit the bill'. She agreed to model for the couturier, 'walked the ramp', and quickly became a 'member of the cabine, which was just like boarding school. I didn't tell my parents, they wouldn't know what modelling was.' (She told them she was in Paris learning French.)

Her career in fashion took off from there: she modelled for Yves and other Parisian designers, travelled the world and started to make jewellery as a hobby. Oscar de la Renta's wife Annette loved Kirat's pieces, as did her sister, and soon her designs appeared in De la Renta's shows and stores, and on the necks, wrists and ears of the rich and famous, from Nan Kempner and Tory Burch to Valentino. Charmingly, Yves kept a photo of Kirat in his Rue de Babylone home; Pierre Bergé explained in an interview in 2011 that she was one of Saint Laurent's favourite models.

CHAPTER 4

HIGH
DRAMA

1980
2000

FEUD: YSL & LAGERFELD

1982

What is high fashion without a delicious, decades-long feud? It started, as all god-tier fallouts do, in a nonsensical way. At 21, Karl Lagerfeld won first prize in the coat category at the International Wool Secretariat, a student design competition (now the International Woolmark prize), but it was Yves Saint Laurent, three years younger, who won the top spot: the coveted evening gown category. Thus began decades of petty jealousies, public meltdowns, a love triangle and an uneasy frenemy status between these two fashion titans.

In their time, both Karl and Yves helmed world-leading fashion houses: Karl at Chloé and Fendi, Yves at Dior. When Yves was the world's top couturier, in 1983, Karl scored the top job: Creative Director of Chanel (even though, years earlier in a TV interview, Coco Chanel had pondered if Yves might be her heir). They also both had relationships with handsome Jacques de Bascher, the cruel 'shadow playboy' of Paris according to one biographer, or a warm, affectionate friend, according to others. Karl and Jacques' relationship spanned 18 years, but Yves and Jacques' torrid six-month secret affair in 1973 was ended by Pierre, who accused Karl of working behind the scenes to damage the rival house. Eventually, Yves and Karl worked their way back to equilibrium: mild but snippy putdowns in the press. De Bascher died in 1989. 'He brought to my life a kind of sparkle nobody else ever will', said Karl to *Vanity Fair* in 1992. 'Maybe there is one person in life for you and that's all.'

INDIAN SUMMER

1982

Watching the world from gilded Parisian apartments or hiding away in his properties in Morocco, Yves was entranced by the exotic lands he was too nervous to visit. This may have caused him to romanticise the art and cultures of other countries; what was a glorious celebration to fashion fans in the early '80s was cringeworthy appropriation to later generations. YSL's Opium was a sexy, louche fragrance on one hand, but seemed to draw on a painful historical addiction epidemic on the other.

Enter Yves' 1982 India-inspired collection – a country and culture he had never experienced first-hand but from where he drew incredible creative power. It was a theatrical collection of sexy, sari-inspired dresses and turbans, like this power look with voluminous skirt in turquoise, and mini bolero and ornate turban in lilac. 'I have been to every country in my dreams,' Yves once said, 'All I have to do to blend into a place or a landscape is to read a book, or look at a picture, and then use my imagination.'

THE PARIS DRESS

1983

The star look of Yves' haute couture Autumn/Winter 1983 collection was a figure-hugging, floor-length black 'Paris' dress, a black velvet sheath frock with saucy slide-split and a ruched pink satin bodice that flowed to a luxurious and impossibly voluminous 'Paris pink' satin bow at the back. Bernadine Morris described the Paris dress and other looks as if the models were wrapped candy boxes, and she was right; the collection was all bright cotton bras and bows tied tight around the hips, and a lot of flesh on show: shoulders, legs, midriffs – it was what Yves called 'the new female sensuality'.

It was also the collection in which Yves launched YSL's new fragrance, Paris, a sort of 'hypnotic floral', according to YSL. Fun fact: the dress was recreated in miniature in 2018 along with Yves Saint Laurent's iconic Saharienne coat and Mondrian dress for a limited-edition Barbie doll, because, well, why not?

YSL OBJECTS

PARIS, THE FRAGRANCE

1983

28 July 1983, and Yves sent Mounia down the runway in a feathered wedding dress (the couture tradition of including a wedding dress in almost every collection made for an exciting moment) clutching a bottle of Yves' latest fragrance, Paris (launched months later, in early December). To describe his latest sensual creation, a heady mix of violet, rose and ylang ylang, Yves used some rather flowery prose: 'Your perfume pins me to a tree. I will never forget it. I will undoubtedly find you again one day. There are a thousand places in Paris where I could see you again and crush your roses against my heart ... For this new fragrance, I have chosen your name because no other is more beautiful. Because I love you. My Paris.'

The brand continues to describe the original 1983 fragrance as Yves' 'eternal lover, his city: Paris', and 35 years later they supercharged Yves' idea with Mon Paris, an even more heady and amorous version of his original creation.

YSL ON SCREEN

ISABELLE ADJANI IN SUBWAY

1985

Legendary French director Luc Besson – he of *La Femme Nikita*, *Léon* and *The Fifth Element* fame – tapped Yves Saint Laurent to dress stars of his early work, *Subway*, featuring Isabelle Adjani and a punky Christopher Lambert. Filmed on the Paris Metro, *Subway* was just about the most stylish mid-80s movie you could see, and Yves had a hand in the look and feel of the film.

By 1982, Yves' mental and physical anguish seemed obvious, and his clients and fashion editors found him to be a tortured genius. Somehow, his creative projects continued at pace: good news for Luc Besson as *Subway* was his first big success – in France and around the world – and made international stars of Christopher Lambert, a thief who takes refuge in the Paris Metro system, and the elegant, perfectly styled Isabelle Adjani, with whom he falls in love. Although Adjani wears 'sharp, hard-shouldered Saint Laurent suiting', it's the 'black tulle ensemble that's guaranteed to make your jaw drop: layers of ruffles atop a grey taffeta full skirt, finished off with diamond bracelets, gigantic face-framing earrings and a spiky bob', writes Radhika Seth in *Vogue*.

THE WHITE FEATHER DRESS, NAOMI

1987

Of all Naomi Campbell's most memorable fashion moments in her decades-long career, this early feathery creation has truly earned its place in Naomi lore. She walked in the Yves Saint Laurent haute couture Autumn/Winter 1987 show, and this piece – as delicate as it was voluminous – took the crowd's breath away. But the exuberance of the feathered frock contrasted with Yves' mood. By 1987, if he wasn't in Paris or Marrakech, he wasn't to be seen at all. Months later he failed to turn up at the reopening of his New York flagship store on Madison Avenue, which it had just had a lavish refit with acres of marble and, in a niche, a fibreglass statue of Venus in shiny red automobile paint (at Yves' personal request); Nan Kempner hosted the relaunch party instead. The muses, Yves' coterie of influential women, always knew when to step in on behalf of the mercurial designer. What's more, by the end of '87, Pierre ruffled more feathers by announcing plans for Yves Saint Laurent to be floated on the Bourse, the French stock exchange, with only 10 per cent of the maison remaining in Yves and Pierre's hands. The move would loosen their grip on the business and perhaps even signified a little financial trouble at the top.

TYRA, AMERICA'S NEXT HAUTE MODEL

1994

Years before securing her pop culture status as an actress, producer and tough TV judge on cult competition show *America's Next Top Model* (the inspiration behind *RuPaul's Drag Race*), Tyra Banks was the couture world's most beloved model. For Yves Saint Laurent's haute couture Autumn/Winter 1994 show, her rich purple and lilac lace look was all about the accessories: a neckpiece with its golden beaten-metal cutouts tumbling down her chest, oversized pendant earrings and a metallic tiara, and headband with floral centrepiece.

By 1994, it was rare to see Yves, even in Paris, and his appearance at his own haute couture show at the Hotel Inter-Continental was met with surprise by some in the crowd. A wonderfully grainy video of the moment exists online, where fashion historian Kattel le Bourhis falls silent as she is nudged out of the way in the crowd by a burly Yves and his heavyset entourage. The video also features younger designers like Olivier Lapidus who seem to have snuck into the lobby to get a glimpse of Yves' magic at work. 'Isn't it wonderful', says Lapidus, 'for the small designer to come see the big designer.'

YSL DESIGNERS

ALBER ELBAZ

1998

PART 1

In 1996, Pierre Bergé appointed Belgian designer Hedi Slimane to head Yves Saint Laurent Men. It was the first time someone other than Yves would be creatively responsible for an aspect of the sprawling and successful business and, although the fashion press waited eagerly for fiery conflict between the fashion king and the little prince, the project was a success – it was only menswear after all. But in 1998, Bergé snapped up another talent, only this time for Yves Saint Laurent's beloved Rive Gauche ready-to-wear line.

Enter the 'smart and kooky Alber Elbaz', according to the *International Herald Tribune*'s Suzy Menkes, with his 'owlish eyeglasses and a mop of curly hair'. The sweetly pudgy Israeli designer – born in Morocco 'and therefore sharing Saint Laurent's North African connection', as Menkes pointed out – had just spent two years gently reanimating another French brand, Guy Laroche. Elbaz had also 'trained in New York during seven years with Geoffrey Beene, one of the rare American designers to work to couture standards.'

But Yves had spent 32 years designing Rive Gauche and was finding the stress and drama of yet another show something he would rather do less of. It had also been noticed that the brand had hit repeat too many times, especially with endless appearances of Yves' iconic safari jacket. No other designer would take on Yves' haute couture collections, reassured Pierre, which would never be passed on, only shut down, if that's what Yves wanted. Hiring Alber was merely to 'protect and comfort Yves', Pierre promised.

YSL DESIGNERS

ALBER ELBAZ

1998

PART 2

Just like at Guy Laroche, Alber did wonderful things at Rive Gauche, even if not everyone agreed. Charged with bringing a little youthful energy to both brands, at YSL he worked from a separate studio, away from Yves, and evolved the brand rather than starting afresh. 'His personal aesthetic – beautiful, womanly clothes that are above all else, wearable – is in keeping with his legendary predecessor's', wrote Elizabeth Hayt in the *New York Times*.

Troublingly, his debut Rive Gauche collection had mixed reviews and Alber – as thin-skinned as Yves – took every snarky comment personally. He was sent on a goodwill tour, visiting Rive Gauche boutiques around the world and talking up the collections with the press, but his next collection received the same mixed reviews. Cathy Horyn, then the *New York Times*' fashion critic said it plainly: 'it just didn't work. Many of the shapes looked bulky ...' and 'one can't help thinking of the sleek style that Hedi Slimane has brought to Saint Laurent men's wear ...' But *Vogue* loved it, writing 'classic Saint Laurent favorites looked better'. Would Alber ultimately replace Yves one day, just as Karl had done at Chanel? It certainly seemed to be possible, and this sheer, feathered look on Alek Wek from Yves Saint Laurent's Autumn/Winter 2000 ready-to-wear show was considered a bullseye hit from the critics (and a wry nod to Yves' own iconic boobs-out designs from the past). But just three collections after his appointment, Gucci swooped in and purchased Yves Saint Laurent, and kooky Alber Elbaz was out, replaced by Texan glamazon, Tom Ford.

"I DO HAVE SOME LETTERS IN HIS HAND. I REMEMBER ONE LINE WAS 'IN THIRTEEN MINUTES YOU'VE DESTROYED 40 YEARS OF MY WORK.'

Tom Ford on Yves Saint Laurent

CHLOË SEVIGNY AT THE OSCARS
2000

In 2019, actress Chloë Sevigny was asked to pick out her all-time favourite red carpet looks. She looked back to the beginning of her career, from Larry Clark's barnstorming *Kids* (1995) and *Gummo* (1997) to *The Last Days of Disco* (1998), through to the much-loved and lauded *Boys Don't Cry* (1999). It was for the latter that she attended the Academy Awards in 2000 in the glow of her Oscar nomination for Best Actress in a Supporting Role, and she chose to wear a dress from Alber Elbaz's Yves Saint Laurent collections. She told the *Los Angeles Times* the dress was 'Alber for Yves Saint Laurent and the Asprey [necklace] was like a Maltese cross. I'd been wearing Alber for YSL for a while and I was going into the archives and wearing vintage YSL ...' Chloë had worn YSL on her Oscar campaign trail leading up to the awards themselves, culminating in this surprisingly sexy YSL silk sheath.

CHAPTER 5

BIG
BUSINESS

'000–14

THE LAST HAUTE COUTURE COLLECTION

2002

As both Yves and Pierre had always claimed, Yves Saint Laurent would rather end his couture legacy himself than have another designer take his place. In a rare move for a maison, he presided over a final couture collection in 2002; a show to rule them all. *Vogue*'s Stephen Todd was there to report on the spectacle and found a living retrospective of Yves' super hits, with supermodels, and super-sized guest list at the Pompidou in Paris. Like all the best goodbye tours, Yves gave the audience just what they wanted: a greatest hits collection. Here was the Safarienne, the Mondrian dress, Naomi in the green fox fur chubby and Claudia Schiffer in a look made famous by Verushka. 'But the Saint Laurent moment par excellence', wrote Todd, 'was Jerry Hall as Marlene Dietrich, vamping in a white ostrich-feather coat over a gleaming white satin gown. As she exited to Roxy Music's 'Love Is the Drug', a bevy of black-velvet full-décolleté dresses was ushered in ...' The era of Yves was over.

YSL WOMEN

NAN KEMPNER

She 'perfectly embodied American elegance', according to the Musée YSL in Paris. US socialite Nan Kempner (1930–2005) was one of the women to have most greatly influenced both Yves Saint Laurent and his brand. A dedicated follower of fashion, Kempner kept great company: legendary *Vogue* editor Diana Vreeland called her the only American woman with any style at all, while Yves' own account of his friend, *'la plus chic du monde'* (the chicest in the world), was something of a step up from *Vanity Fair*'s description of her as 'the world's most famous clotheshorse'. This voluminous evening ensemble – a coat rendered in endless reams of yellow silk faille with its soft, subtle lustre – was created in 1983–84, and worn over a simple black velvet dress.

Of all the YSL women who memorably wore Le Smoking – from Bianca Jagger in a white YSL jacket when she married Mick in 1971, to Françoise Hardy wearing Le Smoking to the opera in Paris where she was heckled ('People screamed and hollered … It was an outrage', Yves Saint Laurent said in an interview in 2005) – it was Kempner herself who earned the best anecdote. In *T: The New York Times Style Magazine* (September 2020), Lindsay Talbot rounds up the outfit's fame-making moments, writing that Kempner was 'famously turned away from the Manhattan restaurant La Côte Basque while wearing the tux (their dress code prohibited women from wearing pants), she slipped off her trousers and turned the blazer into a minidress.' Yves, realising he had a hit, included a version of Le Smoking in each of his collections and the women's tuxedo became part of the house's signature style (by the time of his retirement in 2002, he had designed over 200 of them).

YSL DESIGNERS

TOM FORD

2000

PART 1

Plot twist: in late 1999, the Gucci Group, headed by Domenico De Sole and Tom Ford, snapped up Yves Saint Laurent. Then, after waiting two short months, in the New Year they ousted sweet Alber Elbaz and replaced him with his opposite: the tall, tanned, incredibly toned and commercially minded Ford. His first collection, Saint Laurent Spring/Summer 2001, debuted in a luxurious black tent at Paris's Musée Rodin in October 2000.

Tom Ford is the handsome designer and filmmaker who took the don't-take-no-for-an-answer route to the top spot: after studying architecture at Parsons and working in retail for Chloe, he called American designer Cathy Hardwick again and again until he convinced her to hire him as a design assistant. After more than a decade in the biz he was hired as Gucci's senior women's ready-to-wear designer in Milan. At the time, Gucci was in the doldrums, but Ford ate it up. Behind the scenes, he took over men's ready-to-wear, shoes, the big Design Director role in 1992, and finally the showy Creative Director position in 1994. He transformed the fate of the fashion house, famously sexing it up, persuading the biggest and best stylists, photographers and celebs to pitch in, and in 1999 – the year De Sole and Ford purchased YSL – their Gucci project was valued at $4 billion.

In her profile of previous YSL designer Alber Elbaz in *The New Yorker*, Ariel Levy underlined his contrast with Ford: 'Elbaz is shy and still not exactly a household name', she wrote, 'when Ford guest-edited an issue of *Vanity Fair*, in 2006, he put himself on the cover, flanked by Scarlett Johansson and Keira Knightley in the nude.'

YSL DESIGNERS

TOM FORD

2000

PART 2

But, for the man who was at the epicentre of '90s style, Ford found YSL an odd fit. His monochrome debut collection, based on Betty Catroux, created a buzz, then bombed, and he insisted on designing both Gucci and Yves Saint Laurent collections with a similar sex-positive aesthetic. Even so, he took pains to draw from Yves' earlier work. In 2004, he created this vivid yellow Chinese-inspired dress with pagoda shoulders and dragon motif, inspired by Yves' 1977 China collection. Yves, watching from his couturier's ivory tower, clearly disapproved: 'The poor guy does what he can', he famously said of his successor. But that wasn't the end of it: in the late fashion journalist and stylist André Leon Talley's memoir *The Chiffon Trenches*, he claimed Yves would write Ford poisoned letters; one allegedly said, 'In 13 minutes, you have managed to destroy 40 years of my work.'

Yves closed the couture studio in 2002, drawing the spotlight to him one last time via a spectacular final show, and Ford moved on from Yves Saint Laurent the following year. Six years later, Ford did an interview with *The Advocate* magazine, revealing just what it was like at YSL: 'being at Yves Saint Laurent was such a negative experience for me even though the business boomed while I was there', he said. 'Yves and his partner, Pierre Bergé, were so difficult and so evil and made my life such misery.'

'POLISHED, MATURE, AND PERFECTLY PITCHED'

2004

With all Tom Ford's troubles at Yves Saint Laurent – his clunky and cruel arrival, the alleged animosity from Yves and Pierre – his creative success might be overlooked. He certainly left the house in a better position than when he found it, and his creative direction wasn't bad, either. This gorgeous tonal satin two-piece was slinky and powerfully sexy with pointed shoulders and an Yves-style high collar, although quilted under Ford's direction. It appeared in his final, chinoiserie-inspired collection in 2004, which was 'polished, mature and perfectly pitched', according to *Vogue's* Sarah Mower. She watched on as he 'bowed out smiling, fielding kisses and congratulations with affectionate thanks and a dash of Texan good humour.'

Under Ford, Yves Saint Laurent RTW developed a romantic, sensual edge, and although respectful to the house's past, his final collection was completely and utterly him. As he walked the catwalk at the end of the show, he received a standing ovation from the front row. Later, 'tearing an overwrought woman off the shoulder of his red velvet smoking jacket,' recalled Mower, 'he said, "Oh, come on. I'm just takin' a break, that's all!"'

YSL WOMEN

LOULOU DE LA FALAISE

Belgian designer Fernando Sánchez created racy and lacy lingerie (including two outfits for Madonna's 'Like a Virgin' music video) and lived between Paris, New York and Marrakech. On Sundays, when he was in Paris, he would throw tea parties with 'warm brioche from the boulangerie downstairs, and fat joints of marijuana', according to Alicia Drake in *The Beautiful Fall*. In 1968, at one such party, he introduced Yves and Pierre to Loulou de la Falaise. She was 'stoned and ravishing', in an Ossie Clark chiffon tunic, matching satin trousers, a headscarf and beads; Yves was smitten. A junior editor at *Queen* magazine in London, Loulou had modelled for American *Vogue*, designed prints for Halston, and was from the right sort of old-world lineage: she was the perfect new muse, a role she accepted gratefully (although she was an extremely 'hard-working' muse, she said later in *Vogue* Italia).

Loulou worked for Yves and the maison for 40 years. Starting in 1972, officially across accessories and jewellery, her eccentric personal style influenced Yves and her cheery disposition raised the vibe in the design atelier – she was there every day, offering a positive perspective on Yves' sketches, maintaining a sense of enthusiasm Yves found magical. She became a designer in her own right after Yves' retirement in 2002: accessories, jewellery, clothing and objets, and had two boutiques in Paris.

YSL DESIGNERS

STEFANO PILATI

2004

PART 1

With Tom Ford's departure, it was Stefano Pilati, the Italian designer from Milan, who took over the creative reins of the house. As Ford's second, Pilati had already spent two years working on Yves Saint Laurent's ready-to-wear and accessories lines. But how would Pilati, a one-time assistant designer to design genius Miuccia Prada at Miu Miu, fare at YSL? After all, wasn't it Pierre who, decades earlier, allegedly said, 'Italians don't make fashion, Italians make spaghetti'?

Commercially, Pilati did brilliantly, but with Yves and Pierre? Well, that was another story. His collections were usually well received; his debut collection for YSL in 2005 featured tulip-shaped skirts worn with wide belts that – slowly if not immediately – became an influential style throughout the '00s. Pilati's domed satchel Muse bag was a super-hit (J-Lo and Christina Aguilera loved theirs) as were his YSL Tribute heels. But in 2005, Yves damned him in the press: 'some of what he does is good. Some of it is not so good.'

Rumours suggested there was trouble at the top and, five years on, Pierre 'notoriously excluded Pilati from the gala invite list – *horrors!* – for the YSL retrospective exhibit at the Petit Palais in Paris in 2010', wrote Charlotte Cowles in *The Cut*. Pilati was out in 2012, a year after *The New York Times* credited him with steadying the fashion house that was previously losing around $100 million per year.

YSL DESIGNERS

STEFANO PILATI

2004

PART 2

Nonetheless, his Spring/Summer 2008 collection was a high point. It started with 'a vaguely preppy idea', Pilati told Vogue, 'And then it went into thinking about goddesses, stars.' The stars were rendered in mirrored-plastic geometric tiles connected with metal rings and worn as breastplates with long, slightly asymmetric skirts, looking retro-futuristic. If 2008 was the height of the hippie-edged bohemian look, Pilati was having none of it. 'With each season', wrote Vogue's Sarah Mower, it was 'becoming clearer that Pilati's YSL is on the side of strength, modernity, and the grown-up woman.'

Just as Pilati's star-studded Spring/Summer 2008 collection filtered through to the stores, Yves Saint Laurent was in the final stages of terminal cancer. He and Pierre were able to undertake a *Pacte civil de solidarité* just days before he passed away. The civil union (in France, marriage was only available to same-sex partners in 2013) officially joined the pair who had been in each others' lives for decades.

The funeral was pure Parisian spectacle. Live images of the event were beamed onto giant screens outside the Catholic ceremony where more than 1000 fans had come to pay their respects – and give their applause when Yves' coffin was carried into the Church of Saint-Roch. The fashion greats were all there to say goodbye to both Yves and the era of couture: Vivienne Westwood, Jean Paul Gaultier, Hubert de Givenchy, Christian Lacroix, Sonya Rykiel, and Alber Elbaz with Yves' lifelong friend Catherine Deneuve who read a Walt Whitman poem at the service. Although he had already stepped further and further back from his eponymous brand, the loss of Yves' influence was obvious.

BIG BIRD, BUT MAKE IT FASHION

2010

Channelling *Sesame Street*'s Big Bird, this canary-yellow showpiece ended Stefano Pilati's Saint Laurent Autumn/Winter 2010 ready-to-wear show. Sarah Mower was there for *Vogue*; she seemed to enjoy Pilati's work and was interested in his design direction, even if the occasional collection wasn't a super-hit in the way Yves' work had been back in the day (those endless couture pieces, that endless applause). She thought Pilati's show 'was best in the simplest and strongest pieces: seventies-influenced shapes, like the high-waist flared trousers, capes, mid-calf skirts.'

Pilati clearly wanted to go his own way and not copy Yves' has-beens, but the Italian designer was definitely referencing the 1970s. As this was Yves' sun king era, Mower wondered if it might be easier for Pilati to visit the Petit Palais, 'just opposite the YSL show venue, where a major retrospective of the work of the late Yves Saint Laurent [was] about to open.' Little did she know that when the YSL retrospective exhibit finally began – in a stunning public snub – Pierre Bergé had allegedly forgotten to invite him to the must-attend opening gala.

KATHRYN BIGELOW, AT THE OSCARS

2010

Dressing an Academy Award nominee amounts to big business for a fashion house, especially if that nominee picks up an Oscar – and then breaks the glass ceiling with it. 2010 seemed like it might just be Kathryn Bigelow's year. The director, producer and screenwriter was up for Best Director for her post-invasion Iraq film, *The Hurt Locker*, going head-to-head with her ex-husband, James Cameron, who was also nominated, for *Avatar*. For the event, Bigelow chose a Stefano Pilati for Yves Saint Laurent dress in tight storm cloud-grey satin, with a high slash neck and embroidery on the bodice. What's more, a woman had never won Best Director before.

When the moment came, it couldn't have been camper: two-time Academy Award winner Barbra Streisand was there to hand out the award, pointing out, 'from among the five gifted nominees tonight, the winner could be, for the first time, a woman ...' And it was! Bigelow won, making history.

YSL INSPIRATIONS

RACY ADVERTISING

Banned in the UK, but award-winning in Spain, in 2000 this infamous Opium fragrance ad featuring Sophie Dahl was Yves Saint Laurent at its raciest. The fragrance had always been a controversial addition to Yves' maison. In some ways it was at the very edge of acceptable, but it was also a breathtaking commercial success and had been for decades. Opium launched in 1977, and two years later newspapers excitedly reported that the American Coalition Against 'Opium' and Drug Abuse demanded a name change and public apology from Yves himself 'for his insensitivity to Chinese history and Chinese-American concerns', and for a marketing strategy based on 'a menace that destroyed many lives in China and other countries'. Nevertheless, sales continued to grow.

The 2000 ad, shot by Steven Meisel, was under Tom Ford's tenure, and no wonder: 'One of Ford's more memorable ads as the designer for Gucci', writes Ariel Levy in *The New Yorker*, 'pictured a woman pulling her underwear down in front of a kneeling man to reveal the letter 'G' shaved out of her pubic hair.' Who knows what Yves and Pierre made of the scandal. Neither were Ford fans, but scoring a little controversy was right out of their own playbook.

YSL DESIGNERS

HEDI SLIMANE

2012

PART 1

Before Yves Saint Laurent, Hedi Slimane was simply a skinny fashion wraith, apparating across his native Paris with his equally skinny, trendsetting friends in threadbare vintage band tees, skinny jeans and worn-out leather biker jackets. He studied History of Art at the École du Louvre and assisted Jean-Jacques Picart on an exhibition for Louis Vuitton, but in 1996, with just a tailor's apprenticeship and little other experience, he was hired by Pierre Bergé as Yves Saint Laurent's ready-to-wear menswear director.

YSL Men had scant history, but what was there in the archive seemed to be the perfect launching point for Slimane. He thrived, developing a strong trademark style, and the fashion world noticed. When Madonna wore Yves Saint Laurent to the MTV awards in 1999 it was a fashion moment – and she did it in Slimane's skinny and sensuous men's suit. Then his lauded Autumn/Winter 2000–01 Black Tie collection foreshadowed his 'skinny suits for skinny men' look that became an unstoppable menswear trend in the years to come. But soon, it was all over. Slimane decamped to Dior Homme and became a star there, and that was that – or so it seemed.

YSL DESIGNERS

HEDI SLIMANE

2012

PART 2

In 2012, with high drama, Slimane returned to Yves Saint Laurent, only this time in the top spot as Creative Director, a move that 'proved to be the most contentious undertaking of a brand reinvention in recent memory', said *The New York Times*' Eric Wilson. 'Every week there is a new uproar, from spats with critics to the relocation of his studio.'

Yves Saint Laurent was exciting again! After 'a creative takeover [from Stefano Pilati] that bordered on a coup', said Wilson, Slimane moved the studio to LA, put grunge dresses and floppy boho hats on the runway and banned the journalists who hated them. Out was Yves' beloved Catherine Deneuve, in was Marylin Manson and Courtney Love. Out was Yves himself – Slimane renamed the house Saint Laurent Paris – and out was the sacred font; Helvetica was used instead. Surprisingly, Pierre loved it all (although he no longer had a financial stake in the brand), and so did fashion fans: Slimane sold well. 'When we were buying the collection', Jeffrey Kalinsky (of store Jeffrey New York) told Wilson, 'I felt like I was seeing dollar signs.'

For his then-rumoured final YSL collection in 2016, his go-for-broke, Slimane sent out a 1980s love letter to Yves in the form of this bat-shaped wonder: it was a 'full-on shock', wrote *Vogue*'s Sarah Mower, clearly excited by it all. The collection 'pushed the '80s shoulder to a pinnacle of upstanding exaggeration, drove glittery hemlines up, [and] plunged necklines', she said; 'he is heading off covered in glory.'

YSL MENSWEAR
Spring 2014

Looking back from a contemporary perspective, Slimane's Saint Laurent men's collections from the mid 2010s look a bit obvious, like costumes for trashy LA guitar bands, Brooklyn nepo babies and rich Coachella groupies, but it was Slimane who put these looks on the runway in the first place. He originated these style genres; that's why today they seem so overfamiliar. Hedi's work in the 2000s changed menswear forever.

For Saint Laurent Spring/Summer 2014 menswear, he grabbed from his own cultural obsessions – rough, passionate music, art and technology – and imagined them on a series of bad boys, throwing in a little nostalgia while he was at it. As the 'wasp-waisted, shrunken-chested boy band members' walked by, *Vogue*'s Tim Blanks was there to happily guess Slimane's idols, from Suede's Brett Anderson to New York Dolls' Johnny Thunders. He had no words, though, on this startling look with loose leather biker, Breton stripe top and lurid red PVC trousers. 'Think of it as the most expensive fan letter in history', Blanks wrote.

YSL WOMEN

MARINA SCHIANO

When Marina Schiano passed away in 2019, fashion obituaries tried to capture her outsized influence. *Vogue* called her 'fiery', *The New York Times* wrote about her 'unflappable self-confidence', and *The Times* in London said she 'divided opinion'. She certainly had people talking. Perhaps this is one of the qualities Yves fell for – Schiano was a major Yves Saint Laurent muse, 'one of those rangy, long-haired beauties who traipsed through the pages of *Vogue* in its jet-setting Diana Vreeland days', writes Rachel Felder in *The New York Times*.

The unconventional Italian beauty with the deep, husky voice moved from Naples to New York in the late 1960s, and – due to Yves and Pierre's fascination with her – took on a serious role in 1972, running their YSL Men's boutique and eventually becoming the maison's North American President of Operations. Wearing this outfit, Schiano celebrated the launch of Yves Saint Laurent's wildly popular Opium fragrance in New York in 1978. Later, she became the muse of Calvin Klein, hung out with Andy Warhol's crew, was appointed executive style editor at *Vanity Fair* and became a super-stylist. In 1993, at the height of lesbian chic, she created the heart-stopping cover image of Cindy Crawford giving the singer-songwriter kd Lang a hot shave in a barber's chair; apparently something only the fiery, self-confident Schiano could have pulled off.

CHAPTER 6
MODERN ERA

2014
-24

YSL DESIGNERS

ANTHONY VACCARELLO

2016

PART 1

Anthony Vaccarello was just 34 when he quietly took the top spot at Saint Laurent in 2016. He was determined not to be 'crushed by the weight of Yves Saint Laurent', he told Nick Haramis in *The New York Times* in 2023. Other designers had struggled under the pressure, and Vaccarello also had to contend with the legacy of Hedi Slimane – his dramatic tenure, divisive trash-goth aesthetic, and the way he somehow doubled sales. Vaccarello's mandate, according to Haramis, was not only to offer tribute to Yves, but also to Slimane. To create his own legacy, though, 'Vaccarello knew he'd have to kill more than one father', writes Haramis, clearly a fan of *Game of Thrones*.

But Vaccarello's situation also had its comforts: Yves had died in 2008 (so there was no one to offer barbed putdowns in the press) and Pierre – who seemed to have softened – gave Vaccarello his blessing, telling him: 'Please do your own version of Saint Laurent; try to never copy him.' And Slimane had designed Saint Laurent from a studio in LA; the only imprint he'd left in Paris was – by chance – a gorgeously renovated design space that was now ready to be occupied.

Vaccarello had most recently worked for Donatella Versace overseeing Versace's Versus line, and from her 2023 perspective, she said, 'he's the best designer they've had at Saint Laurent. And I'm so happy for him because, yes, he wanted this. But also, he didn't want it.'

YSL DESIGNERS

ANTHONY VACCARELLO

2016

PART 2

Vaccarello's slight awkwardness is attributed by some to growing up gay in conservative Brussels, taking the wrong career path (law; he was inspired by TV show *Ally McBeal*), and a period of depression before gaining the support of his family to pivot into fashion. He quickly honed a personal design style: less avant garde, more intelligently wearable. He worked at Fendi, then set up his own brand with his husband and design partner, Arnaud Michaux, and was then snapped up by Donatella who, with her entourage, requested his presence in her hotel suite: Vaccarello was in awe! Under Donatella, he grew Versus, further developed his style and joined Saint Laurent.

Although his first Saint Laurent collections didn't quite hit the mark, he was 'superconfident' by Saint Laurent's Autumn/Winter 2019 collection three years later, writes *Vogue*'s Nicole Phelps. This collection, with looks that seem to have been inspired by Betty Catroux, also featured this evening ensemble: an architectural 1980s wonder with one impossibly oversized shoulder, because why not?

Vaccarello's other inspirations are cinematic, and fashion films (sometimes in place of IRL shows) have been part of his Saint Laurent output, collaborating with cult filmmakers Wong Kar-Wai and Jim Jarmusch as well as writer Brett Easton Ellis. In 2023 Vaccarello made it official and founded Saint Laurent Productions, which has made Pedro Almodóvar's *Strange Way of Life* and films directed by David Cronenberg, Jacques Audiard and Paolo Sorrentino.

YSL OBJECTS

THE KATE BAG

2010

Louboutin heels, a Louis Vuitton clutch, a pink-toned lipstick by Charlotte Tilbury, even a dry shampoo: Kate Moss had inspired any number of products. In 2010, Stefano Pilati's troubled Yves Saint Laurent era, the maison named their latest accessory after her.

The cute-as-anything party bag, used as a clutch or cross-body, and with or without a tassel, is emblazoned with A. M. Cassandre's gorgeous YSL script logo from 1963 – and has become a hit. Moss has had a long love affair with Yves Saint Laurent. She was the brand's go-to for runway shows in the '90s and '00s, famously modelled for an Opium print advert in 1993, and appeared in Anthony Carrello's racy fashion film for Saint Laurent in 2013. There, on a Capri helipad (where else?), with the wind tousling her hair, she represented the brand, naked but for a white fur coat and boots. Although the supermodel has been spotted with other Saint Laurent bags, from the Easy, Downtown and Muse Totes to Hedi Slimane's Classic Duffle, it's the Kate for the win.

LE SMOKING BIANCA JAGGER REDUX

2016

In 2016, human rights activist and onetime queen of clubland Bianca Jagger spent a day at the Dior Resort show at Blenheim Palace in an outfit that echoed both her disco days and rock star wedding. Decades earlier, in May 1971 to be exact, Bianca Pérez-Mora Macias made fashion history with an unconventional bridal outfit. As she married The Rolling Stones' Mick Jagger in St. Tropez, and in lieu of a traditional wedding dress, she wore an ivory-toned Le Smoking jacket from Yves Saint Laurent with a bespoke bias-cut column skirt, and little else. Like all the best fashion moments, Bianca's look was surprising, and more than a little sexy: not only was she wearing what seemed to be a men's tux jacket, she simply buttoned it up without a blouse or bra, adding a veiled sun hat and clumpy, ankle-strapped peep-toe sandals – and looked incredibly chic and insouciant as she did it.

The men's off-white Le Smoking jacket – not always, but often, Saint Laurent – became part of Bianca Jagger's signature style. She has revisited it again and again over the decades, sometimes with a natty black ribbon 'Western' bow or a loosely knotted tie at her neck. Black and white photographs of rare moments inside New York's Studio 54 show Bianca in countless outfits, but none so iconic as her timeless Le Smoking look.

YSL WOMEN

PALOMA PICASSO

Yves and Pierre were art lovers; no wonder Paloma Picasso, Pablo's young daughter, found herself in their Paris orbit. Initially, Paloma was very shy. She told Alicia Drake in *The Beautiful Fall* that she was sensitive to the attention she drew from being her famous father's daughter, and dressed eccentrically 'as a way to shift the attention from the person I was to what I was wearing'; but what was 'a shield' to some was fascinating to Yves and the wider fashion and art set.

Paloma's style – at odds with her fellow Parisian elites – was refreshing, and her love of vintage pieces inspired Yves' hugely influential Scandal collection. In fact, she is credited with electrifying Yves out of his haute couture mindset and into a more creative, forward-thinking state. Paloma worked in theatrical costume design, another passion of Yves', and made jewellery from vintage rhinestones picked up at flea markets, or, as Manolo Blahnik remembers more romantically, 'crystal flowers ... from cemeteries in the South of France.'

Yves commissioned Paloma to create her own collection, which she launched at his Rive Gauche boutiques in Paris. Later, she worked with photographer Horst P. Horst, who documented artists and those in the creative industries in amusing tableaus for a series of fashion portraits for *Vogue* in 1983, including this shocking-pink panelled button-up. In 2022, Anthony Vaccarello revisited Paloma's personal style for the Saint Laurent Spring/Summer show close to the Eiffel Tower. *Vogue*'s Mark Holgate was there and saw how 'Vaccarello celebrated her legacy in audacious and fabulous style'.

YSL OBJECTS

THE LOULOU
2017

Although there might be a little excitement in colourways, tassels and textures, Saint Laurent bags are thought of as classics: 'if you are concerned about longevity,' says *Vogue*, 'Saint Laurent is a wise investment'. What seems to be advertorial speak might just be true of the Loulou, the smart quilted wonder launched in 2017 that looks like it might just be from decades past. Creative Director Anthony Vaccarello named this accessory after Loulou de la Falaise, the delightful Saint Laurent queenpin who passed away in 2011. Vaccarello continues to create excitement at Saint Laurent; one by one he has introduced a series of new accessories, and searches for Saint Laurent bags at luxury fashion retailer Net-A-Porter saw a 203 per cent increase between May '23 and May '24. The Loulou has a classic and classy envelope shape with a slightly flared bottom, a firm structure, generously padded chevron quilting and A. M. Cassandre's 1963 YSL interlocking script logo in gold.

GOOD CLOTHING IS A PASSPORT TO HAPPINESS.

Yves Saint Laurent

YSL ON SCREEN

PEDRO PASCAL IN *STRANGE WAY OF LIFE*

2023

Yves loved costume design, creating outfits – and sometimes sets – for film and theatre. If the maison's starting point was dressing Catherine Deneuve in Luis Buñuel's *Belle de Jour* in 1967, decades later Saint Laurent Productions is not just dressing celebrities but making its own movies. Enter cult director Pedro Almodóvar and his Spanish-Western short comic film, *Strange Way of Life,* starring Pedro Pascal and Ethan Hawke as a pair of rootin' tootin' cowboys who reunite after 25 years. Almodóvar described *Strange Way* as a 'queer Western' on Dua Lipa's podcast (where else?), as she spent '24 Hours in Madrid' with the much-loved auteur known for his brightly toned melodramas like *Women on the Verge of a Nervous Breakdown* and *Kika*; 'it's about masculinity in a deep sense because the Western is a male genre', he continued.

Film geek and Saint Laurent Creative Director Anthony Vaccarello serves as producer and costume designer, and dresses Pascal and Hawke (and the actors who play their impossibly handsome younger selves) in classic Western gear, given the Almodóvar hyper-colour treatment.

REMEMBER BRAT SUMMER? CHARLI XCX

2024

The endless lime-toned memes and lo-res merch, the intensity of feeling, and how whatever it was seemed to die before it truly lived? On 1 September 2024, its creator, Essex cool girl Charli XCX, posted 'goodbye forever brat summer', and that was that. Ostensibly to promote her new smart pop album, also called *brat*, Charli XCX kickstarted a fleeting cultural phenomenon; she was riding high in her career, and it was the perfect time for almost any fashion house to dress her. Enter Saint Laurent.

Just before brat summer, Charli XCX attended the Saint Laurent and *Vanity Fair* pre-Oscars dinner in early 2024 to celebrate *Oppenheimer* (the annual event is a useful predictor of whatever film is going to do well), wearing Anthony Vaccarello's floor-length sheer dress with a cropped biker jacket, an echo of Yves' own Beatnik-inspired couture piece in 1960. Billed as Saint Laurent by Anthony Vaccarello in the accompanying photo story in *Vanity Fair*, the brand dressed many of the celebs present that night in dark sheer fabrics, high-gloss black leather and more than a few Le Smoking suits for the *Oppenheimer* hopefuls, and Charli XCX, a smouldering brat-bomb about to go off.

SHEER STYLE

2024

In the summer of 2024, on the world-stopping *Emily in Paris* junket, ahead of the fluffy but fashion-focused Netflix TV show's new season, the cast popped up in LA. There, on a helipad at golden hour, the cast artfully arranged themselves for a group shot in the latest, runway-fresh looks. Testament to the power of the show – or the influence of its costume designer, stylist Patricia Field – Saint Laurent was pleasantly over-represented.

Not many but actress Philippine Leroy-Beaulieu could pull off a version of this sheer look from Saint Laurent Autumn/Winter 2024, a collection that was famously 48 looks of almost completely transparent pieces rendered in 'I kid you not, the same fabric that's used for tights', remarked *Vogue*'s Mark Holgate. It seemed an audacious move but, as Holgate points out, sheer looks had been present on the red carpet and runways in previous years, only not quite in Vaccarello's numbers. But freeing the nipple like this is a Saint Laurent original move, ever since Yves' used sheer fabrics in 1966.

YSL ON SCREEN

SELENA GOMEZ IN *EMILIA PÉREZ*

2024

In the summer of 2024, Selena Gomez, Zoe Saldaña, Karla Sofía Gascón and Adriana Paz, the stars of Jacques Audiard's semi-operatic, Spanish language drama *Emilia Pérez*, were at the Cannes film festival, heavily promoting their project and generally looking lovely. The film was co-produced by Saint Laurent Productions and the cast were often styled in Saint Laurent for their many sun-kissed photo ops; Saint Laurent Creative Director Anthony Vaccarello even served as producer on the film itself. Their glam campaign worked: the unique four-act thriller about women pursuing their own happiness in modern-day Mexico (including an eyebrow-raising musical number about vaginoplasty) won not just the Jury Prize but also Best Actress for its ensemble cast.

Playing Jessi, a gangland boss's wife, in an operatic indie film was arguably the most out-there role that onetime teen pop star Gomez had ever contended with. It was as if she were throwing off her vanilla, slightly chaste persona for good, and French costumier Virginie Montel with Saint Laurent's own Vaccarello were there to help her emerge. They dressed Gomez in several Saint Laurent looks, from a metallic sheer blouse to a raglan-sleeve Rive Gauche ringer tee, but the key image has her in this Spring/Summer 2022 ready-to-wear long-sleeve romper from a collection inspired by Yves' own muse and friend Paloma Picasso. With its deep V-neck, soft but serious shoulder pads, tie-waist, '70s rose print and lithe, sensual silhouette, it has an element of disco fever, and Gomez gives it real grown-up glamour.

YSL INSPIRATIONS

YVES' LOVE CARDS

1970–2007

As a young teen, Yves created miniature imaginary worlds, dressed paper dolls in haute couture and sketched make-believe ensembles to win the International Wool Secretariat design competition, twice. Illustration was an integral part of Yves' creative process, perhaps most evident in his graphic LOVE cards, created almost every year from 1970 to 2007. Each card – printed and sent to friends, associates and collaborators to commemorate the year – has delightfully illustrated typography and the same word: love.

Many of Yves' cards are inspired by Morocco (there is a small LOVE gallery at the Jardin Majorelle in Marrakech with every card on display), but others are in homage to Yves' favourite artists, from his friend and contemporary Warhol, to Matisse, and even Yves and Pierre's beloved Jean Cocteau. In September 1970, Warhol and Yves spent time together in Paris. Warhol was filming *L'amour* (a surreal comedy featuring Karl Lagerfeld), and the pair discovered a shared aesthetic. After Warhol left town, Yves experimented with collage, inspired by the American Pop artist, and the first LOVE card was born. Today, the LOVE designs are truly loved, especially the handmade originals. A music-themed LOVE card from 1980, rendered in felt-tip by Yves himself, sold for more than £47,000 in 2022. But others have appeared on more fun, inelegant items: posters, a gym bag, even umbrellas and home-printed tees, each one the kind of intertwining of high and low culture that Yves adored.

> YVES SAINT LAURENT SURVIVED IN FASHION ON THE STRENGTH OF WHAT HE CREATED. HE INVENTED A STYLE AND, WHEN THERE WAS NO MORE TO INVENT, HE SET ABOUT PERFECTING IT.

Alicia Drake

ABOUT THE AUTHOR

Dan Jones is a British author living in New York. Formerly of *i-D* magazine and *Time Out London*, he's an expert in style, cocktails and queer mythology. He is the author of a number of books including two of the previous titles in this series, *Style Icon: Diana* and *Style Icon: Dior*.

ABOUT THE ILLUSTRATOR

Currently based in Barcelona, Sandra Suy has been working as a freelance illustrator for more than 10 years, with an emphasis on fashion and beauty. She believes in the strength of details and simplicity as a means to achieve maximum expressiveness. She enjoys experimenting with textures, superimpositions, prints and collage, but always tries to maintain minimalism in the image. Less is more. Sandra finds inspiration in all kinds of creative expressions including music, fashion, art, books and nature.

ACKNOWLEDGEMENTS

Thanks to: Marie Clayton, Chelsea Edwards, Max Edwards, Juliette Hughes, Danny Lim, Tom McDonald, Gaynor Sermon, Dr Erman Sözüdoğru, Sandra Suy and Claire Warner.

INDEX

A
Adjani, Isabelle 98
AIDS 8

B
Banks, Tyra 102
Barbie 94
BDSM 8, 46
Beatnik Look (1960) 18, 162
Beatniks 18, 22, 26
Belle de Jour (1967) 46, 56, 160
Bergé, Pierre 8, 20, 34, 50, 78,
 82, 86, 104, 120, 128, 130, 136
 A Moroccan Passion 72
Bigelow, Kathryn 132
Blahnik, Manolo 154
Bousquet, Jean 82
Bowles, Hamish 44
Broadway Suit (1978) 80
Brunhoff, Michel de 14
Buñuel, Luis 46, 160
Burch, Tory 86

C
Campbell, Naomi 64, 100, 114
Cardinale, Claudia 32
Carlu, Jean 34
Cassandre, A. M. (Mouron,
 Adolphe Jean-Marie) 34, 156
Catroux, Betty 50, 72, 120, 148
Chanel, Coco 90
Charli XCX 162
'Chicago' leather jacket (1960)
 18, 28, 162

Chloë 90
Clark, Ossie 28, 124
Colin, Paul 34
Crawford, Cindy 142

D
Dahl, Sophie 70, 134
De Bascher, Jacques 90
De La Falaise, Loulou 72, 78,
 124, 156
De La Renta, Oscar 86
Deneuve, Catherine 46, 56,
 138, 160
Deroche, Dominique 24
Dietrich, Marlene 42, 114
Dior 7–8, 16, 18, 20, 44
 debut at Dior (1957) 14
Dior, Christian 7, 14, 16
Drake, Alicia *The Beautiful Fall*
 22, 28, 72, 78, 124, 154, 171

E
Elbaz, Alber 104–6, 110, 118
Elizabeth II 46
Emilia Pérez (2024) 166
Emily in Paris 164

F
Fellini, Federico 32
Fendi 90, 148
Ford, Tom 50, 106, 109,
 118–22, 126, 134
fox fur coat (1971) 64

G
Gomez, Selena 166
Graphéine 34
Gucci 106, 118, 120, 134
Guy Laroche 104, 106

H
Hall, Jerry 70, 84, 114
Hawke, Ethan 160
High Seas Chic (1978) 82

I
India collection (1982) 92
International Wool Secretariat
 7, 12, 90

J
Jagger, Bianca 116, 152
Jardin Majorelle, Marrakech
 8, 66, 168
Jones, Grace 78
jumpsuit (1968) 52

K
Kate bag (2010) 150
Kempner, Nan 86, 100, 116
knitted bridal gown (1965) 40

L
La Grande Dame 40
Lagerfeld, Karl 8, 12, 24, 76,
 80, 90, 168

Lalanne, Claude and
 François-Xavier 54
Le Figaro 24
Le Palace, Paris 78
Le Smoking (1966) 42, 44, 48,
 116, 152, 162
Leroy-Beaulieu, Philippine 164
Les Espagnoles et les Romantiques
 (1977) 74
Louis Vuitton 136, 150
Loulou bag (2017) 156
Loupot, Charles 34
LOVE cards (1970–2007) 168
Luquet de Saint Germain,
 Danielle 44

M
Madonna 124, 136
Majorelle, Jacques 66
Matisse, Henri 84
Max et les Ferrailleurs (1971) 62
Mississippi Mermaid (1969) 56
Mondrian Dress (1965) 16, 36,
 40, 42, 94, 114
Mondrian, Piet 36, 84
Mon Paris (fragrance) 96
Moss, Kate 150
Mugler, Thierry 76
Muñoz, Anne-Marie 24
Muñoz, Carlos 24
Musée YSL, Paris 14, 20, 32,
 34, 50, 56, 80, 116
Musée Yves Saint Laurent,
 Marrakech 8, 66, 72

N
New York Times 14, 20, 34,
 36, 48, 50, 54, 60, 74, 76,
 80, 84, 86, 106, 126, 138, 142, 146
*New York Times Style
 Magazine* 116
Nude Look 44, 52

O
Observer, The 52
Opium (fragrance) 70, 92
 advertising controversy 134
Orosemane, Mounia
 76, 80, 82, 96
Oscars 110, 132

P
paper dolls 8, 12
Paris (fragrance) 94–6
Paris dress (1983) 94
Paris Match 12
Pascal, Pedro 160
Pea coat (1962) 22
Peterson, Patricia 20
Picasso, Pablo 84
Picasso, Paloma 84, 154, 166
Pilati, Stefano 126–30
Pink Panther, The (1963) 32
Porgy & Bess 76, 80

Q
Quant, Mary 28
Quinn, Richard 40

R
Rive Gauche 18, 42, 50, 56,
 60, 104, 106, 154, 166
Robin Hood inspiration (1963) 28
Rouet, Jacques 14

S
Saharienne (safari jacket)
 (1968) 48, 94
Saint Laurent Productions 148, 160
Saint Laurent, Brigitte 12
Saint Laurent, Lucienne 7, 12
Saint Laurent, Michèle 12
Saint Laurent, Yves 7–8, 39,
 69, 159
 first YSL collection (1962) 20, 22
 last haute couture collection
 (2002) 114
Scandal collection (1971) 60
Schiano, Marina 142
Schiffer, Claudia 114
Schneider, Romy 62
Sevigny, Chloë 110
sheer style (2024) 164
Sinoir, Paul 66
Slimane, Hedi 104, 106,
 136–40, 146, 150
Strange Way of Life (2023)
 148, 160
Streisand, Barbra 132
Subway (1985) 98

T
Talley, André Leon
 The Chiffon Trenches 120
Théâtre de l'Athénée, Paris 12
Trapeze Line (1958) 16
Trench coat (1962) 22

V
Vaccarello, Anthony 44, 50,
 146–8, 154, 156, 160, 162, 164, 166
Valentino 86
Van Gogh, Vincent 84
Vanity Fair 90, 116, 118, 142, 162
Versace, Donatella 146
Versace, Gianni 76
Veruschka 54, 114
Victoire 82
Vogue 12, 14, 40, 48, 62, 98,
 106, 114, 116, 122, 124, 128, 130,
 138, 140, 142, 148, 154, 156, 164

W
Warhol, Andy 72, 142, 168
white feather dress (1987) 100
Women's Liberation 16, 42

Y
Y (fragrance) 34
Young, Kirat 86
YSL menswear (2014) 140

Quadrille, Penguin Random House UK,
One Embassy Gardens, 8 Viaduct Gardens,
London SW11 7BW

Quadrille Publishing Limited is part of the Penguin Random House group of companies whose addresses can be found at:
global.penguinrandomhouse.com

Penguin Random House UK

Copyright © Dan Jones 2025
Illustrations © Sandra Suy 2025

Dan Jones has asserted his right to be identified as the author of this Work in accordance with the Copyright, Designs and Patents Act 1988

Penguin Random House values and supports copyright. Copyright fuels creativity, encourages diverse voices, promotes freedom of expression and supports a vibrant culture. Thank you for purchasing an authorised edition of this book and for respecting intellectual property laws by not reproducing, scanning or distributing any part of it by any means without permission. You are supporting authors and enabling Penguin Random House to continue to publish books for everyone. No part of this book may be used or reproduced in any manner for the purpose of training artificial intelligence technologies or systems. In accordance with Article 4(3) of the DSM Directive 2019/790, Penguin Random House expressly reserves this work from the text and data mining exception.

Published by Quadrille in 2025

www.penguin.co.uk

A CIP catalogue record for this book
is available from the British Library

ISBN 9781784887971
10 9 8 7 6 5 4 3 2 1

Publishing Director: Kate Pollard
Managing Editor: Chelsea Edwards
Designer: Claire Warner Studio
Copyeditor: Marie Clayton
Proofreader: Gaynor Sermon
Indexer: Helen Snaith
Senior Production Controller: Martina Georgieva

Colour reproduction by p2d

Printed in China by RR Donnelley Asia Printing Solution Limited

The authorised representative in the EEA is Penguin Random House Ireland, Morrison Chambers, 32 Nassau Street, Dublin D02 YH68.

MIX
Paper | Supporting responsible forestry
FSC® C018179

Penguin Random House is committed to a sustainable future for our business, our readers and our planet. This book is made from Forest Stewardship Council® certified paper.